# ONE
## NATION
# UNDER
# DOG

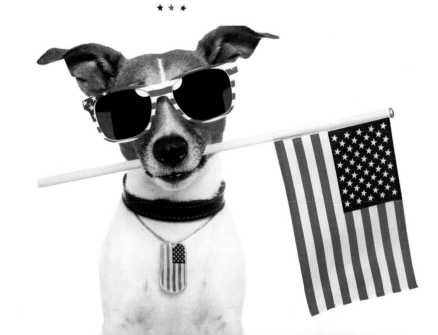

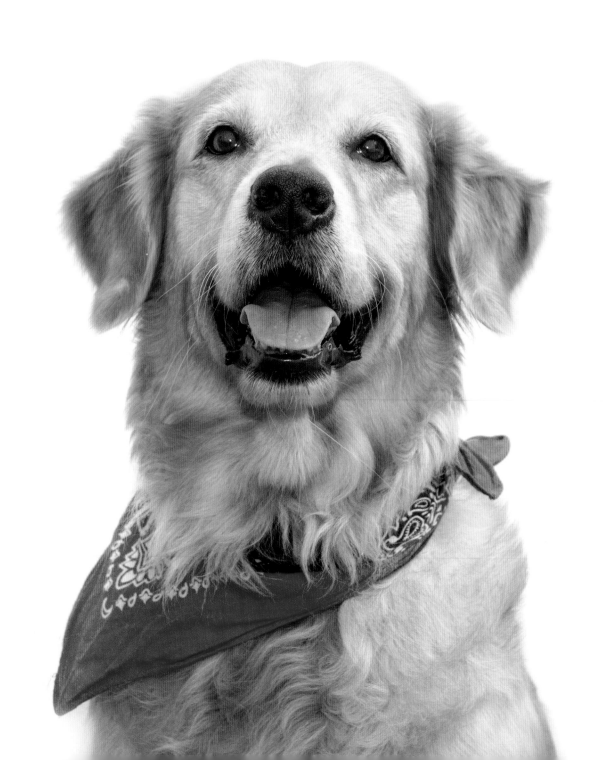

# ONE
# NATION
# UNDER
# DOG

★ ★ ★

PATRIOTIC POOCHES

FROM ACROSS AMERICA

★ ★ ★

## MARY ZAIA

Castle Point Books
New York

www.castlepointbooks.com

The Castle Point Books trademark is owned by Castle Point Publishing, LLC.
Castle Point books are published and distributed by St. Martin's Press.

ISBN 978-1-250-27400-7 (hardcover)
ISBN 978-1-250-27401-4 (ebook)

Design by Tara Long
Composition by Mary Velgos
Edited by Monica Sweeney

Our books may be purchased in bulk for promotional, educational, or business use.
Please contact your local bookseller or the Macmillan Corporate and Premium Sales Department
at 1- 800-221-7945, extension 5442, or by email at MacmillanSpecialMarkets@macmillan.com.

First Edition: 2020

10 9 8 7 6 5 4 3 2 1

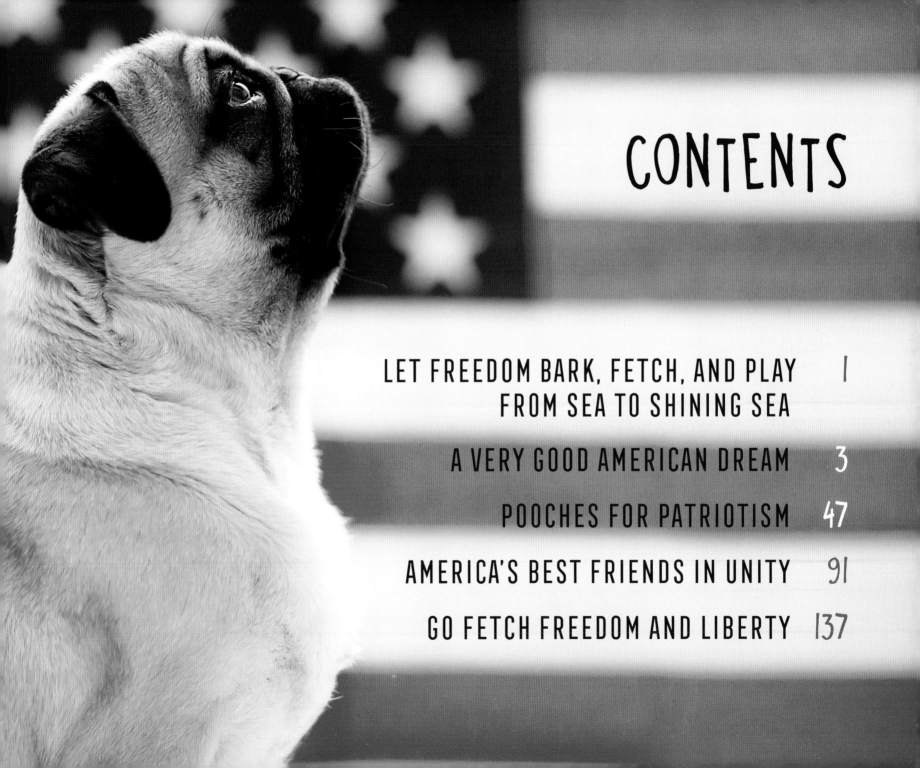

# CONTENTS

# LET FREEDOM
## BARK, FETCH, AND PLAY
## FROM SEA TO SHINING SEA.

Nothing embodies the American dream quite like the unrelenting energy, boundless enthusiasm, and playful heart of a dog. In *One Nation Under Dog*, you can embark on the joyful exploration of what it means to love the good old U.S. of A. through the eyes of four-legged friends. This tribute to America's best friends comes complete with inspiring words of wisdom from powerful voices who have expressed the values we hold dear alongside photographs of cute dogs and puppies at play, at rest, or adorned in red, white, and blue. Celebrate the life, liberty, and pursuit of happiness that these patriotic pooches run after so majestically on the pages of *One Nation Under Dog!*

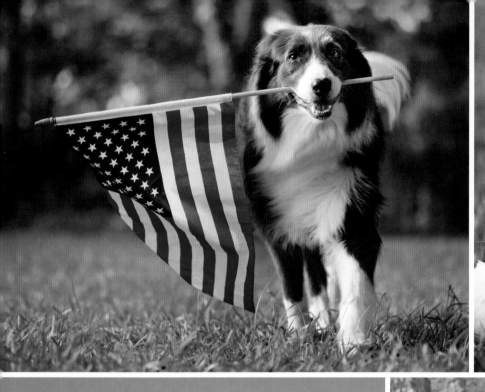

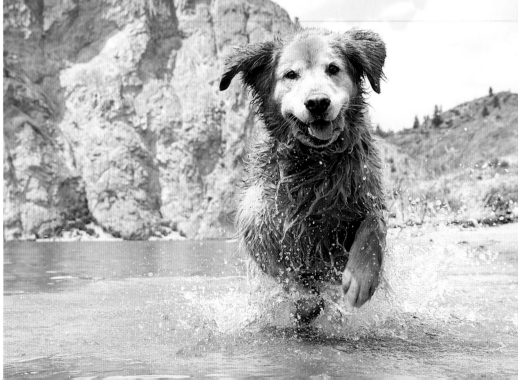

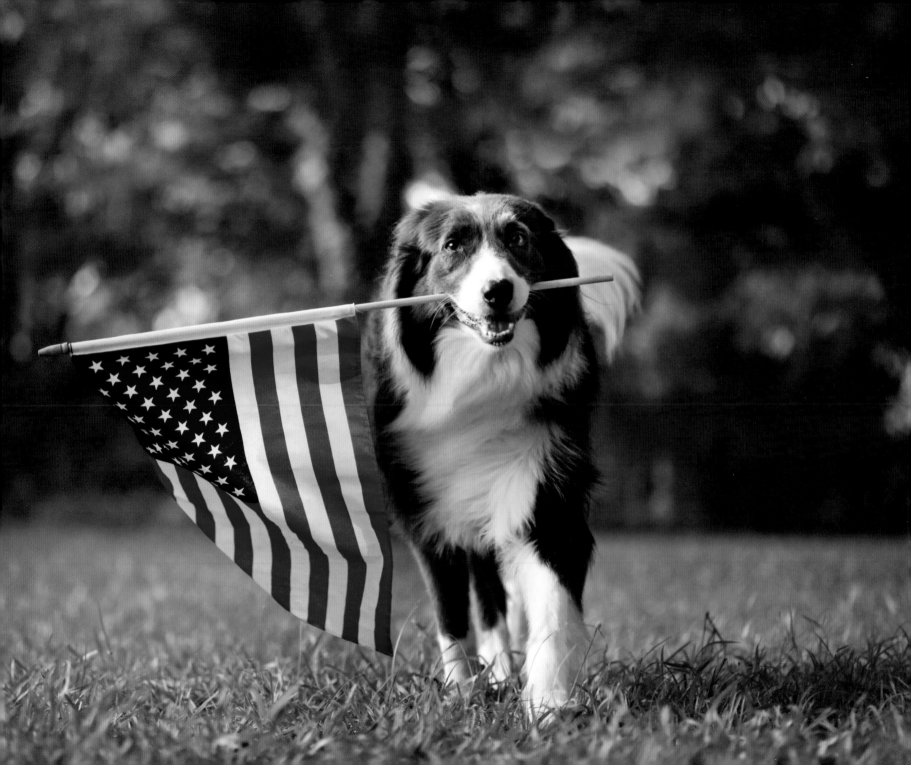

# AMERICA WAS BUILT
## ON COURAGE,
## ON IMAGINATION, AND
## AN UNBEATABLE DETERMINATION.

HARRY TRUMAN

# AMERICA IS A LAND OF OPPORTUNITY, AND DON'T EVER FORGET IT.

WILL ROGERS

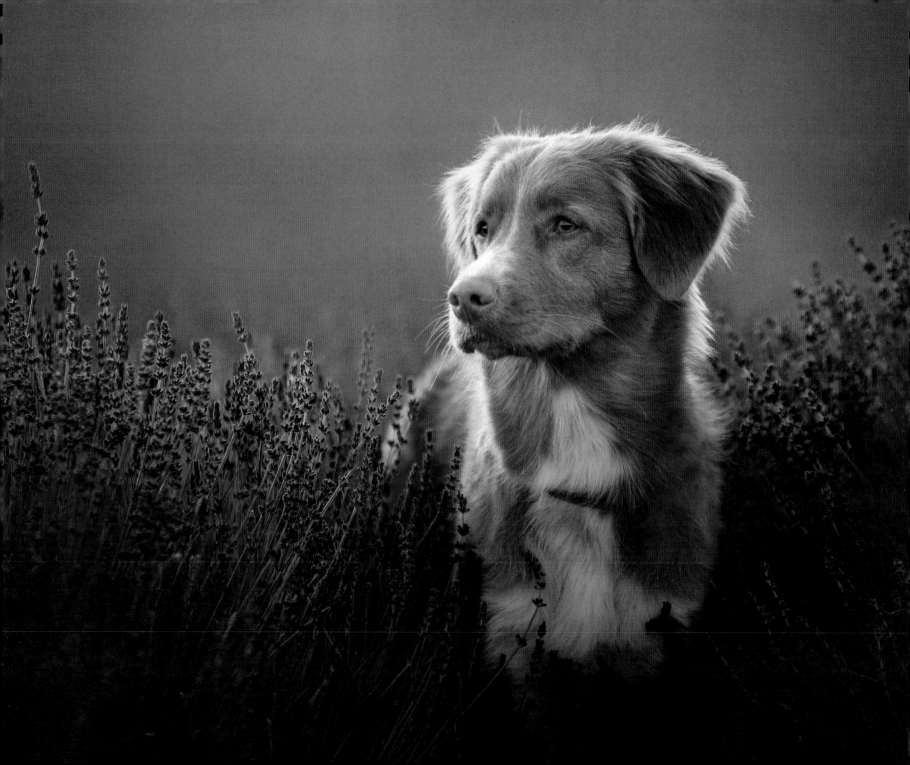

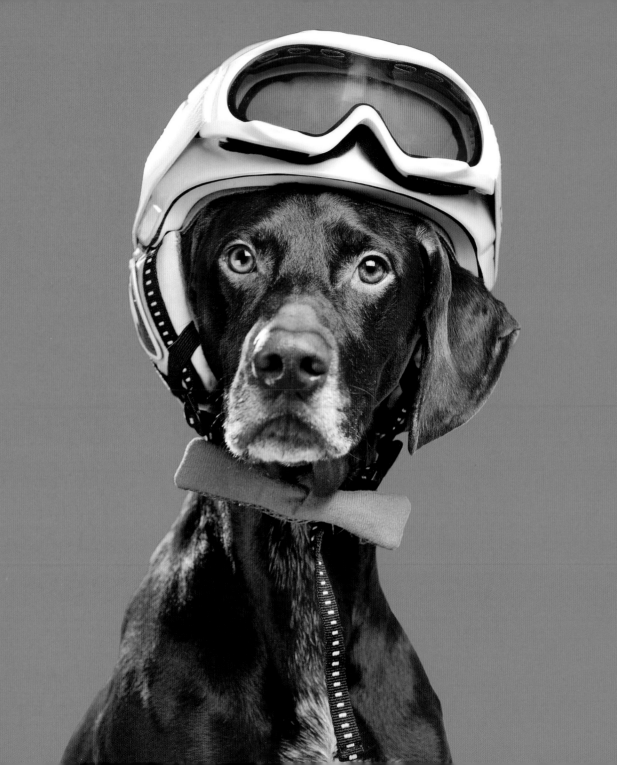

WE ARE CALLED THE NATION
OF INVENTORS. AND WE ARE.
WE COULD STILL CLAIM THAT TITLE
AND WEAR ITS LOFTIEST HONORS
IF WE HAD STOPPED WITH THE
FIRST THING WE EVER INVENTED,
WHICH WAS HUMAN LIBERTY.

MARK TWAIN

# AMERICA IS NOT JUST A COUNTRY, BUT A WAY OF LIFE.

ANONYMOUS

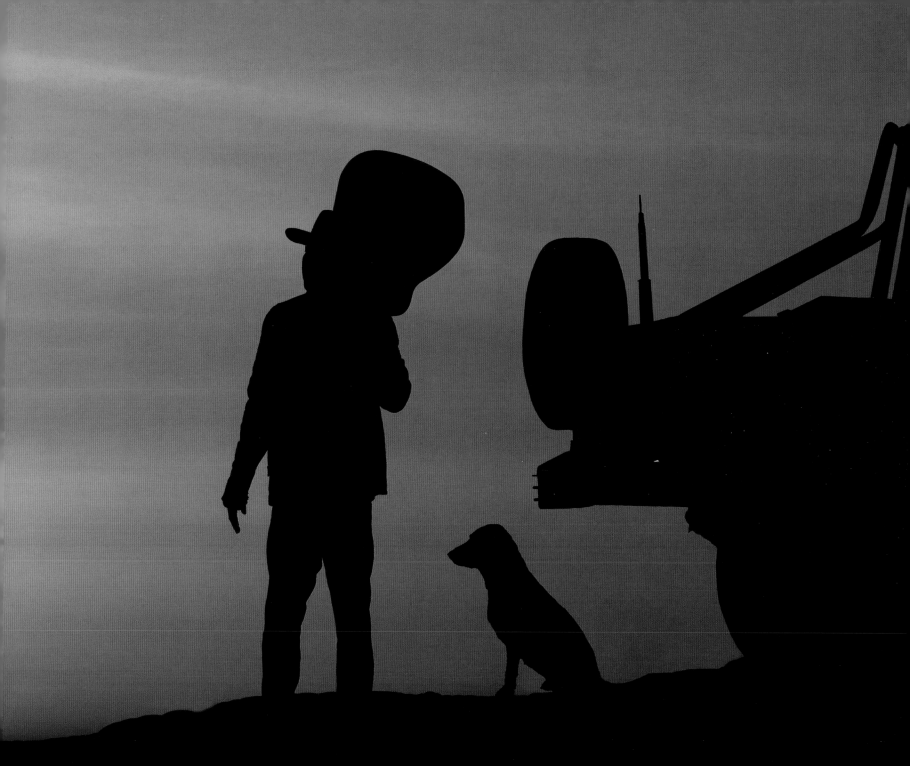

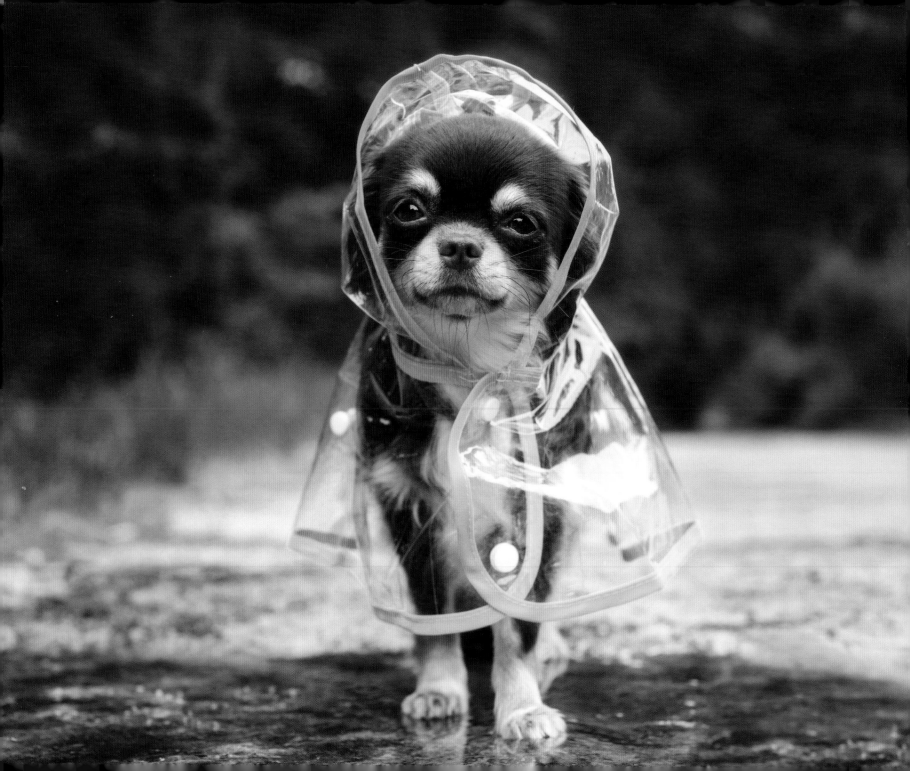

# OURS IS THE ONLY COUNTRY DELIBERATELY FOUNDED ON A GOOD IDEA.

JOHN GUNTHER

EVERY GREAT DREAM BEGINS WITH A DREAMER. ALWAYS REMEMBER, YOU HAVE WITHIN YOU THE STRENGTH, THE PATIENCE, AND THE PASSION TO REACH FOR THE STARS TO CHANGE THE WORLD.

HARRIET TUBMAN

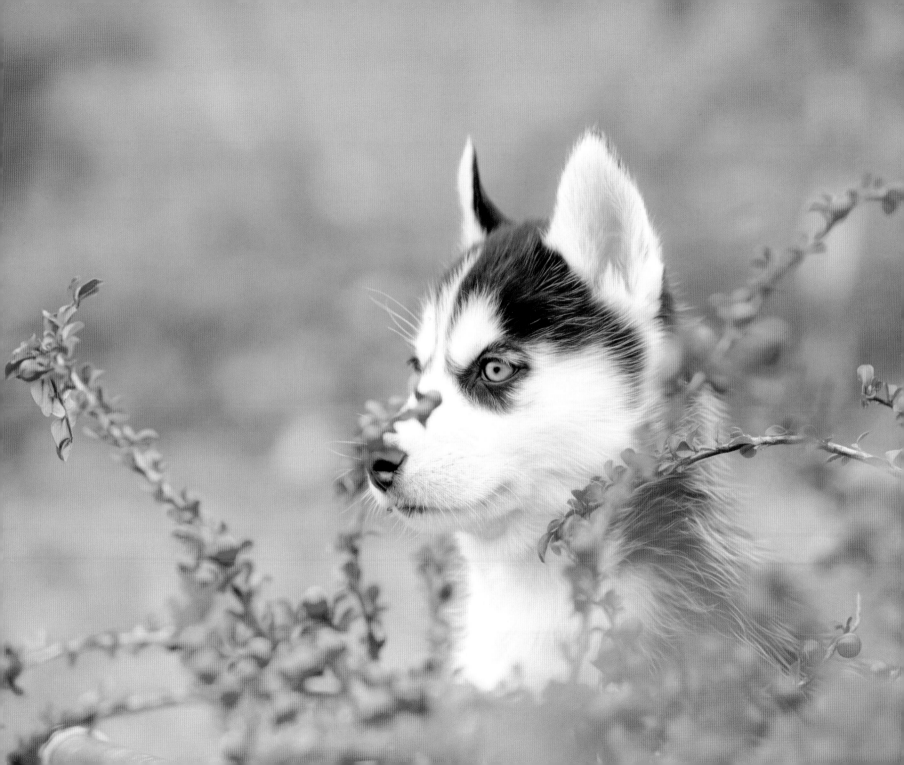

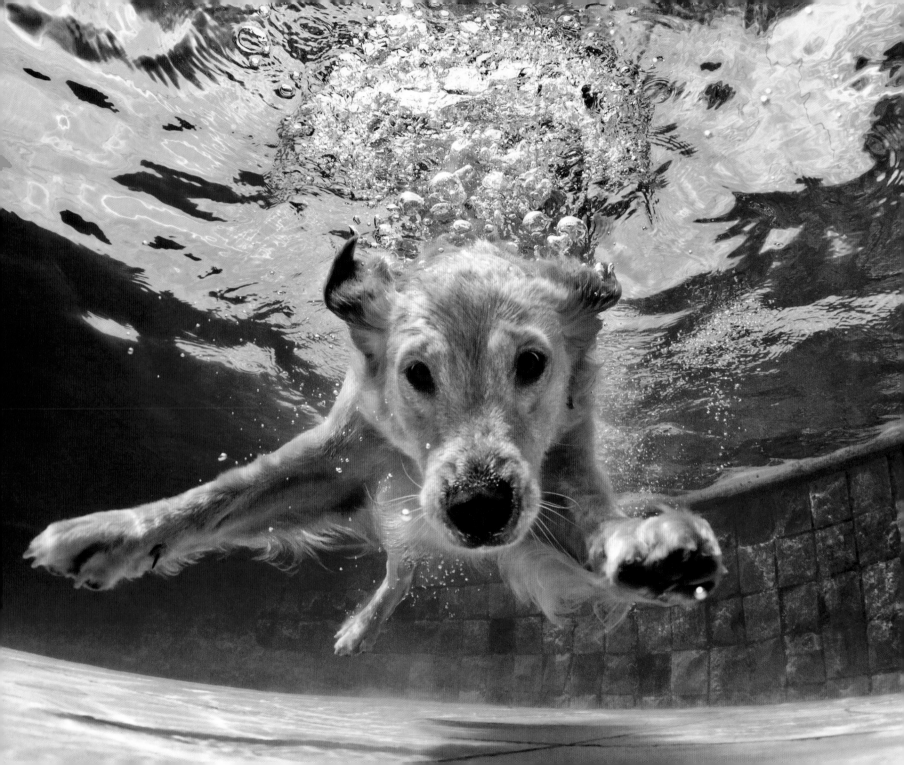

# IF YOU TAKE ADVANTAGE OF EVERYTHING AMERICA HAS TO OFFER, THERE'S NOTHING YOU CAN'T ACCOMPLISH.

GERALDINE FERRARO

# IN THE UNLIKELY STORY THAT IS AMERICA, THERE HAS NEVER BEEN ANYTHING FALSE ABOUT HOPE.

BARACK OBAMA

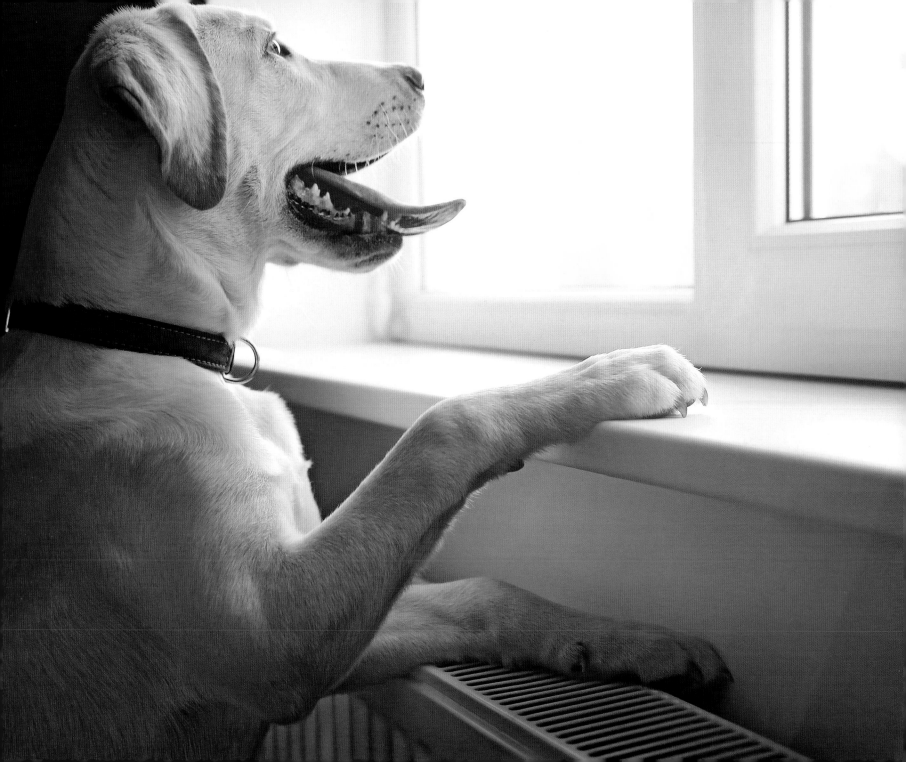

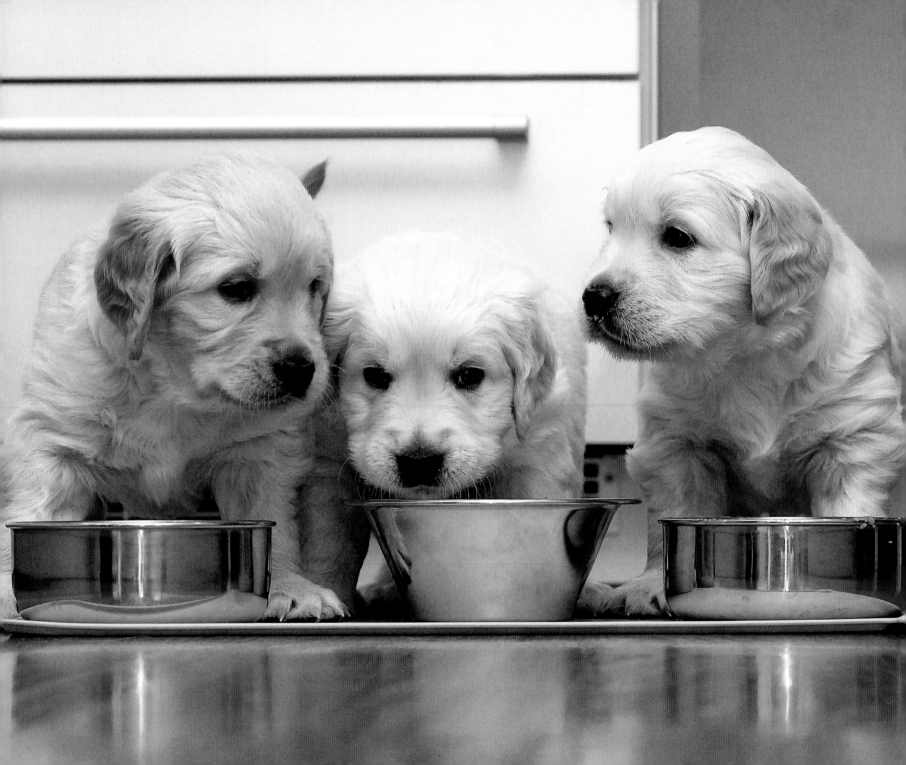

# ALL GREAT CHANGE
# IN AMERICA
# BEGINS AT THE DINNER TABLE.

RONALD REAGAN

THE ESSENCE OF AMERICA — THAT WHICH REALLY UNITES US — IS NOT ETHNICITY OR NATIONALITY OR RELIGION — IT IS AN IDEA . . . THAT YOU CAN COME FROM HUMBLE CIRCUMSTANCES AND DO GREAT THINGS.

CONDOLEEZZA RICE

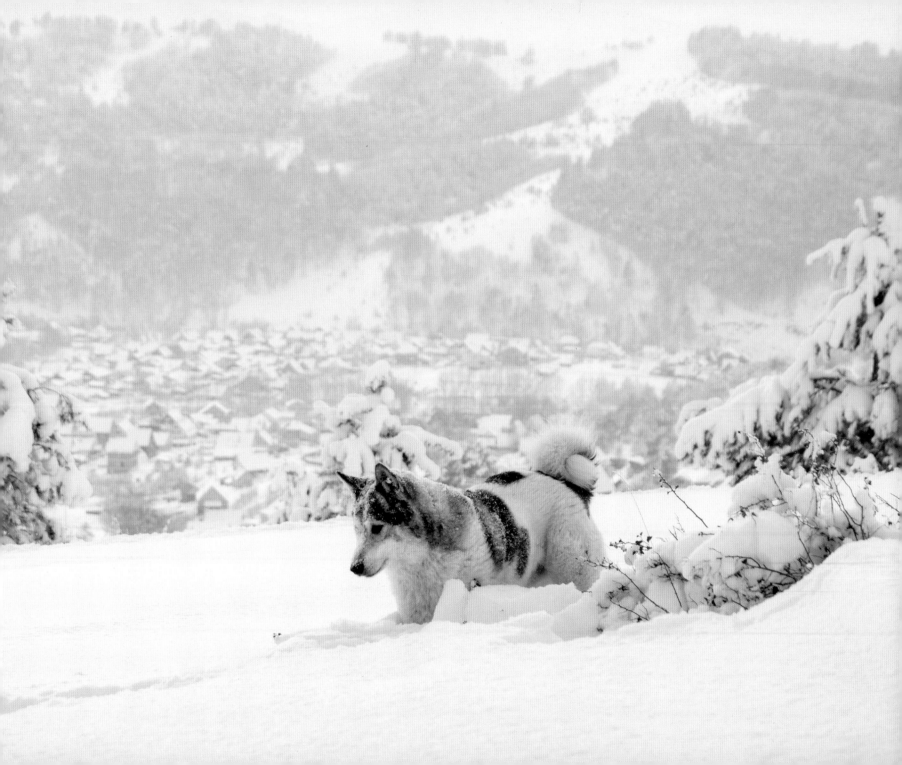

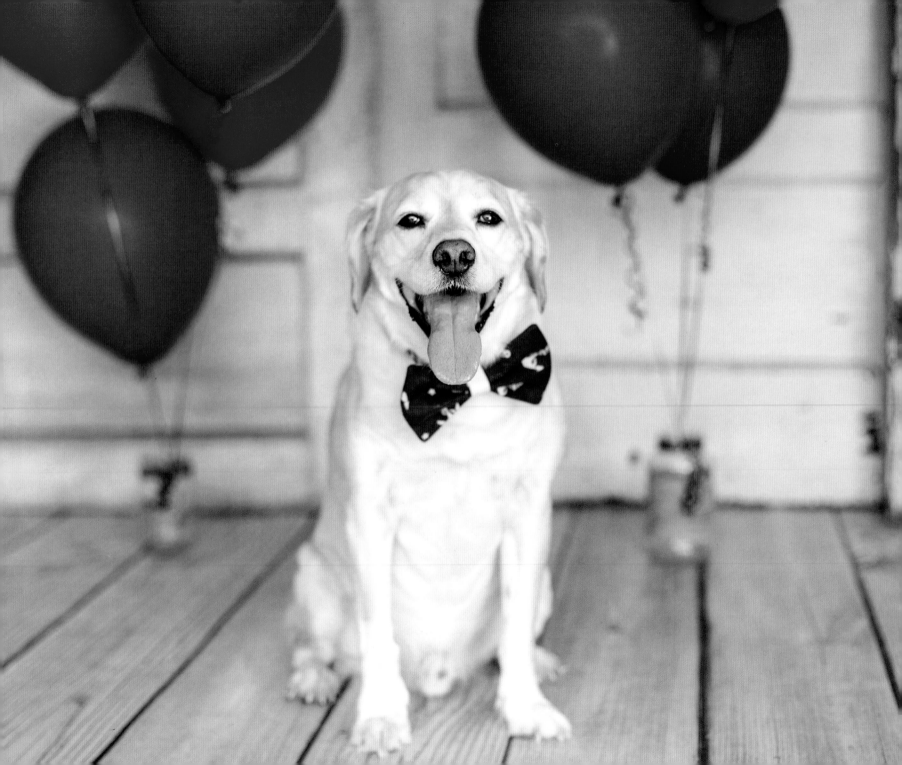

# THE AMERICAN, BY NATURE, IS OPTIMISTIC.

## HE IS EXPERIMENTAL, AN INVENTOR AND A BUILDER WHO BUILDS BEST WHEN CALLED UPON TO BUILD GREATLY.

JOHN F. KENNEDY

# THERE IS NOTHING WRONG WITH AMERICA THAT CANNOT BE CURED BY WHAT IS RIGHT WITH AMERICA.

BILL CLINTON

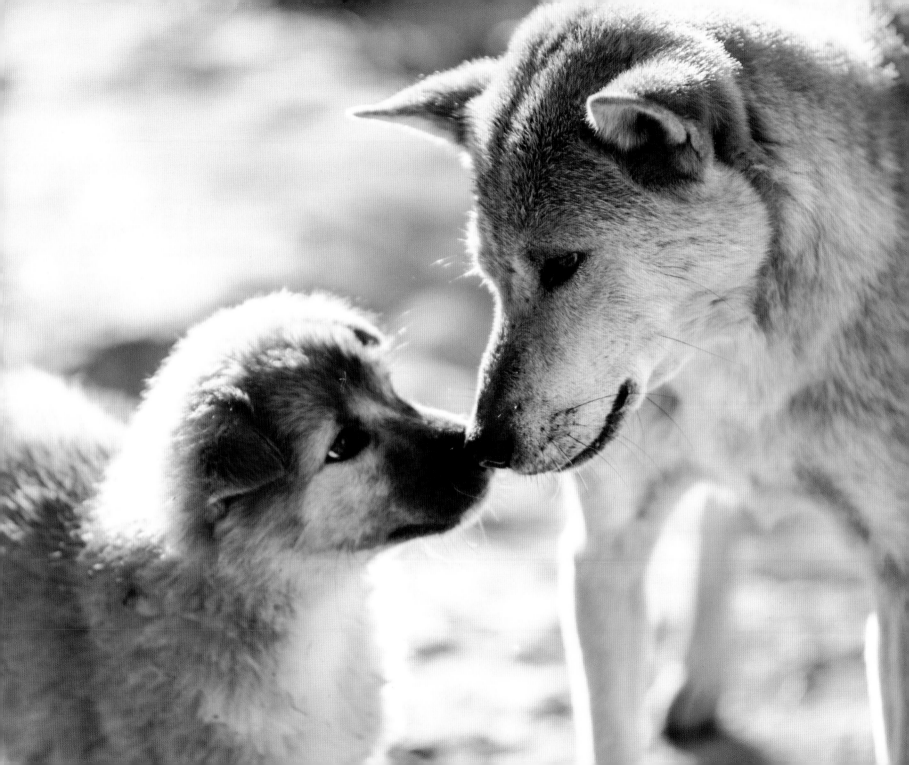

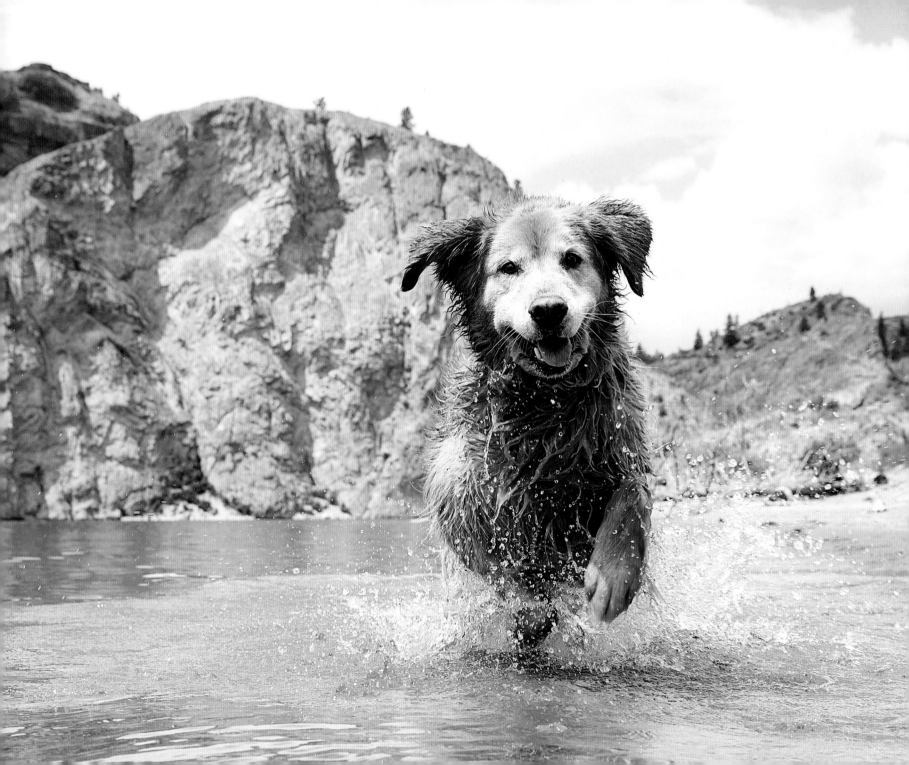

# AMERICA IS ANOTHER NAME FOR OPPORTUNITY.

RALPH WALDO EMERSON

FOR ALL MY LIFE, AMERICA
WAS THE PLACE TO BE. AND WE
SOMEHOW CONTINUE TO BE
THE PLACE WHERE THERE ARE REAL
OPPORTUNITIES TO CHANGE THE WORLD
FOR THE BETTER.

JAMES WATSON

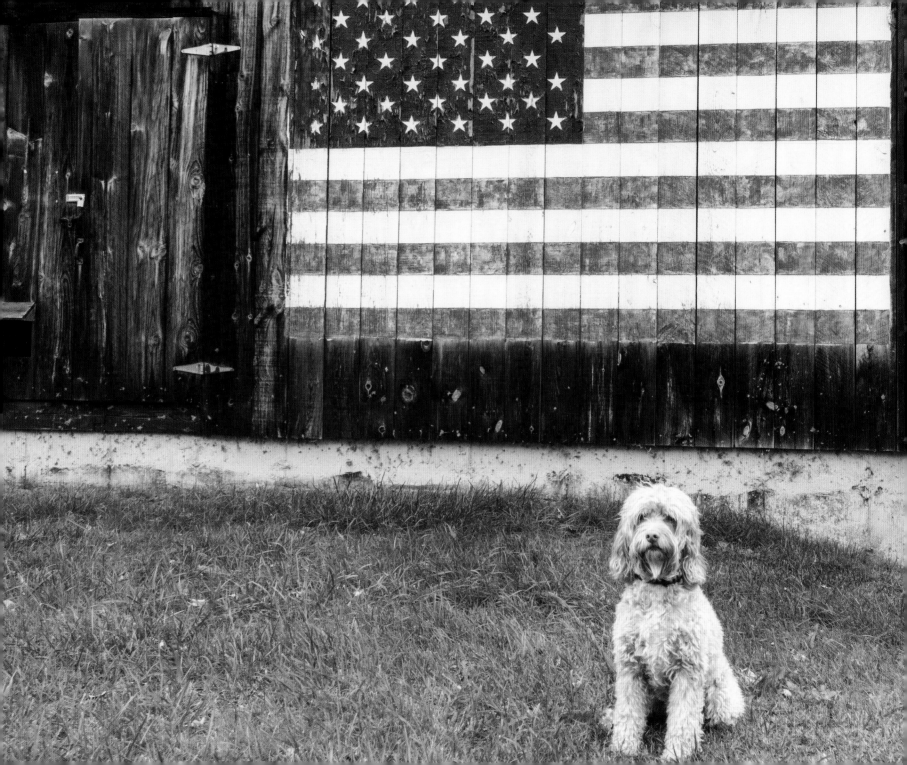

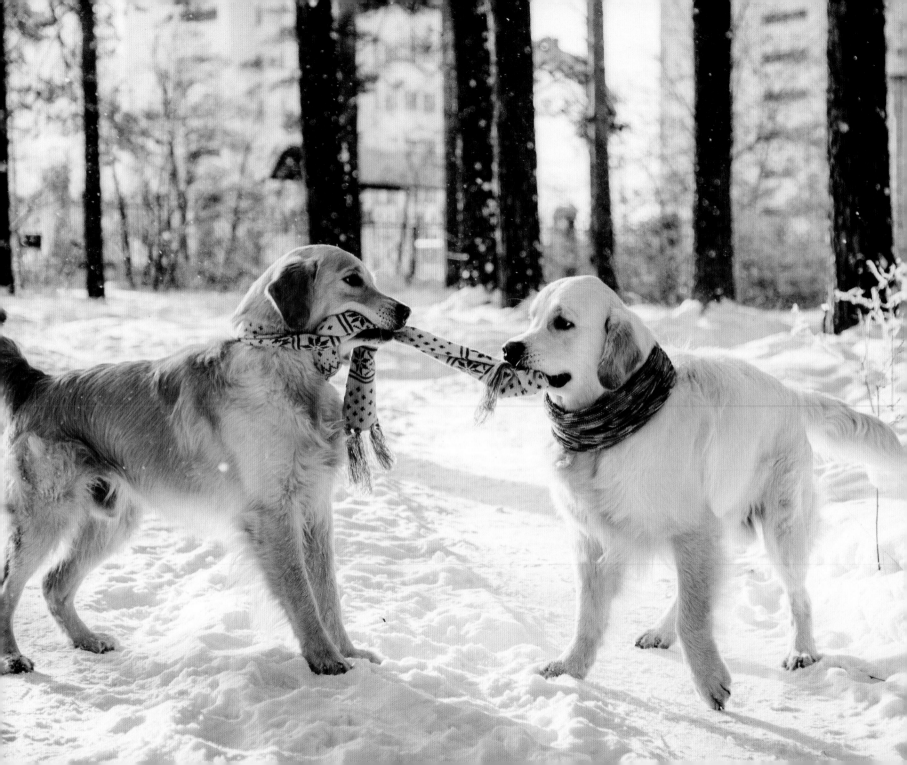

# THE AMERICAN DREAM BELONGS TO ALL OF US.

KAMALA HARRIS

AMERICANS ARE FIGHTERS. WE'RE TOUGH, RESOURCEFUL, AND CREATIVE, AND IF WE HAVE THE CHANCE TO FIGHT ON A LEVEL PLAYING FIELD, WHERE EVERYONE PAYS A FAIR SHARE AND EVERYONE HAS A REAL SHOT, THEN NO ONE—NO ONE CAN STOP US.

ELIZABETH WARREN

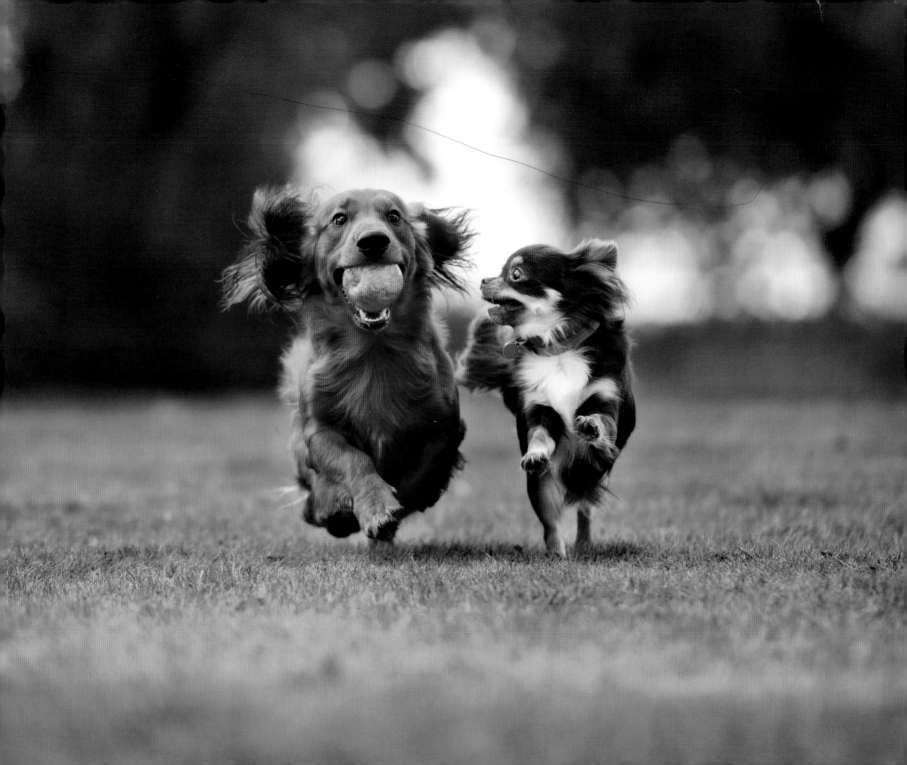

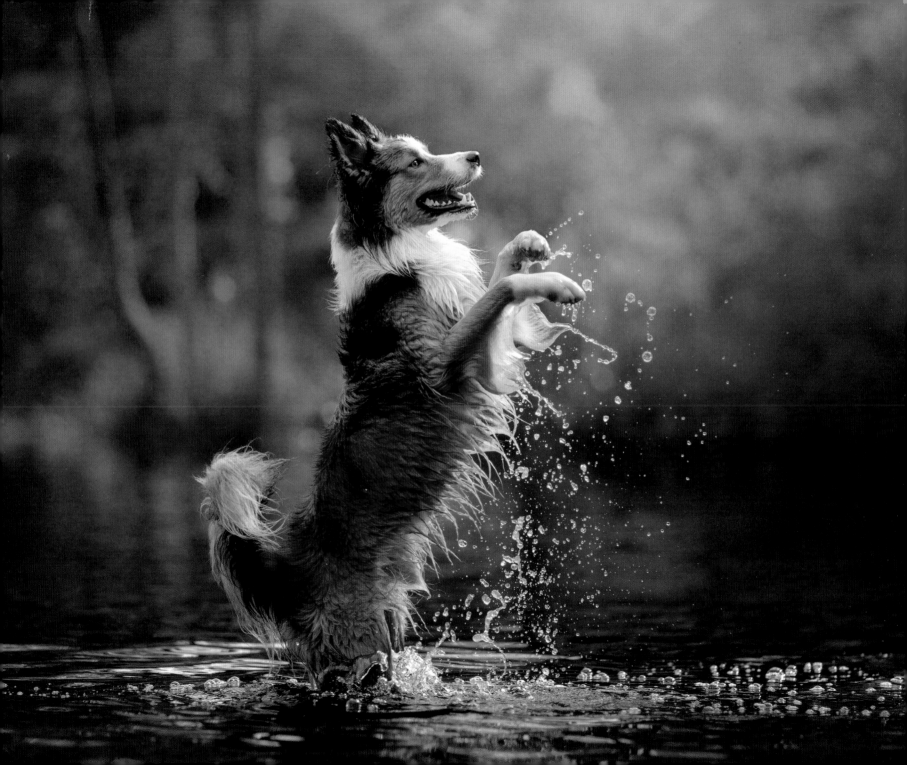

# THE FUTURE IS NOW.
# ROLL UP YOUR SLEEVES AND
# LET YOUR PASSION FLOW.
# THE COUNTRY WE CARRY
# IN OUR HEARTS IS WAITING.

BRUCE SPRINGSTEEN

THE AMERICAN DREAM I BELIEVE IN
IS ONE THAT PROVIDES ANYONE
WILLING TO WORK HARD ENOUGH
WITH THE OPPORTUNITY TO SUCCEED.

TAMMY DUCKWORTH

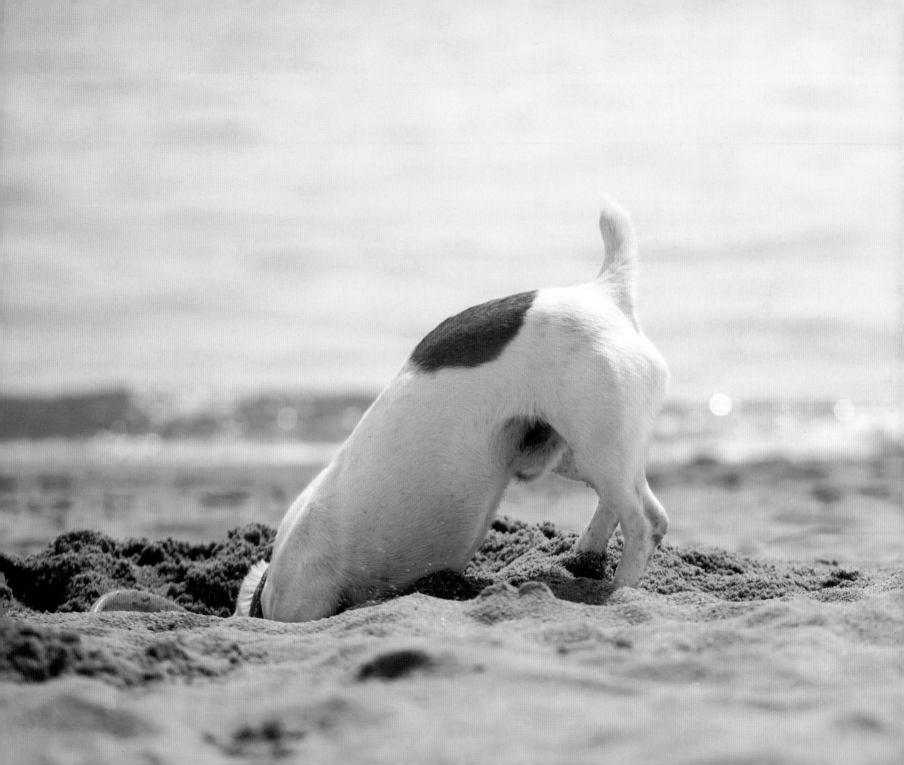

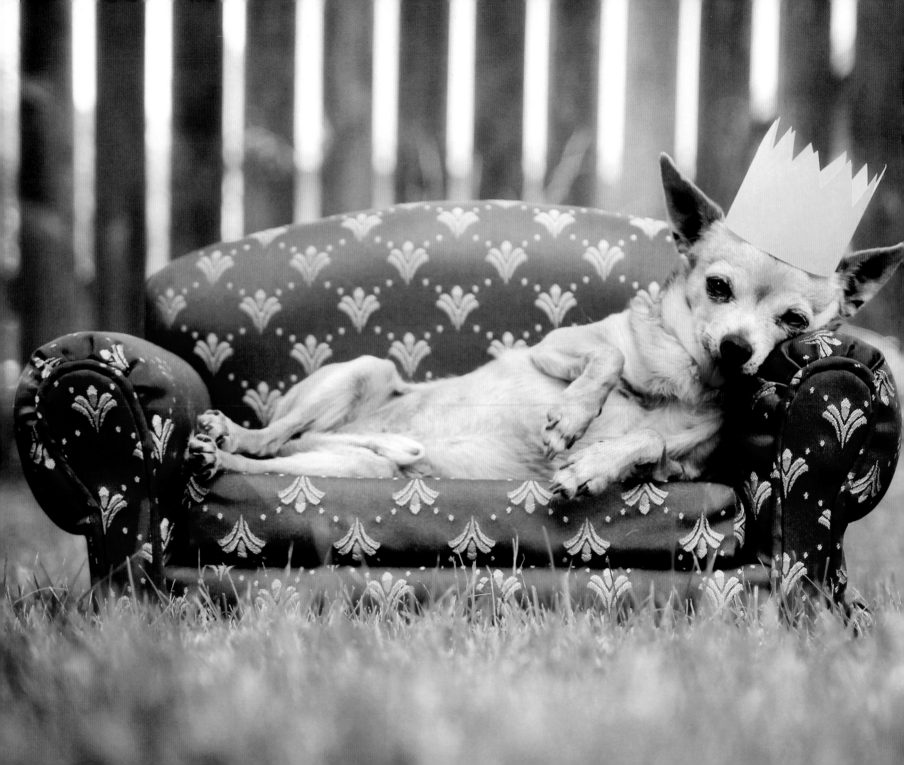

# THE AMERICAN DREAM REMINDS US THAT EVERY MAN IS HEIR TO THE LEGACY OF WORTHINESS.

MARTIN LUTHER KING, JR.

# THE AMERICAN DREAM IS THAT DREAM OF A LAND IN WHICH LIFE SHOULD BE BETTER AND RICHER AND FULLER FOR EVERYONE, WITH OPPORTUNITY FOR EACH ACCORDING TO ABILITY OR ACHIEVEMENT.

JAMES TRUSLOW ADAMS

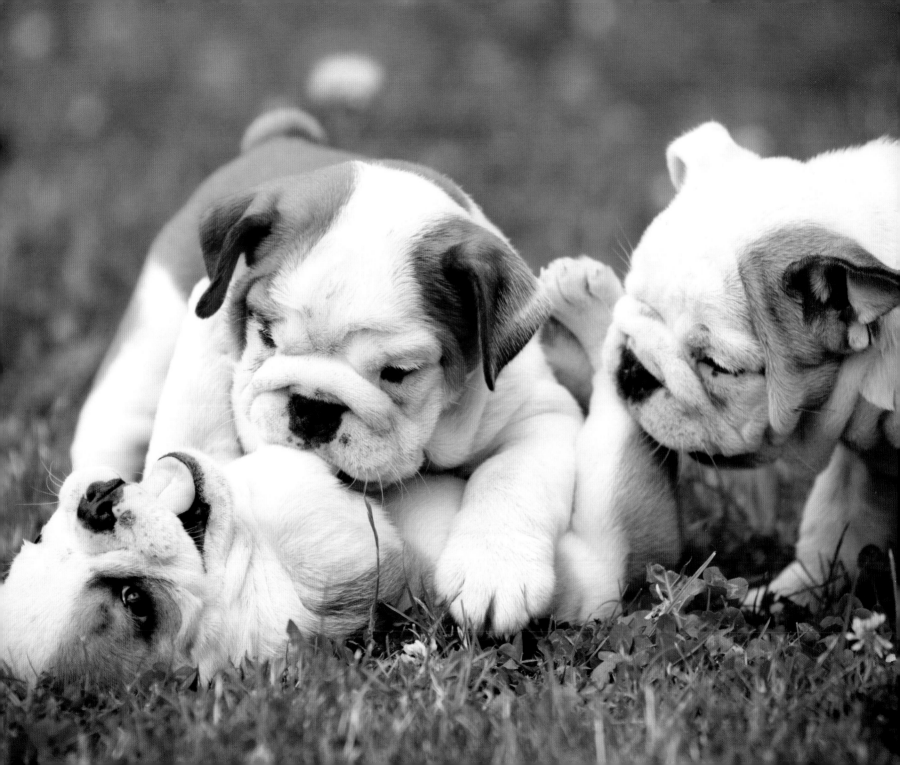

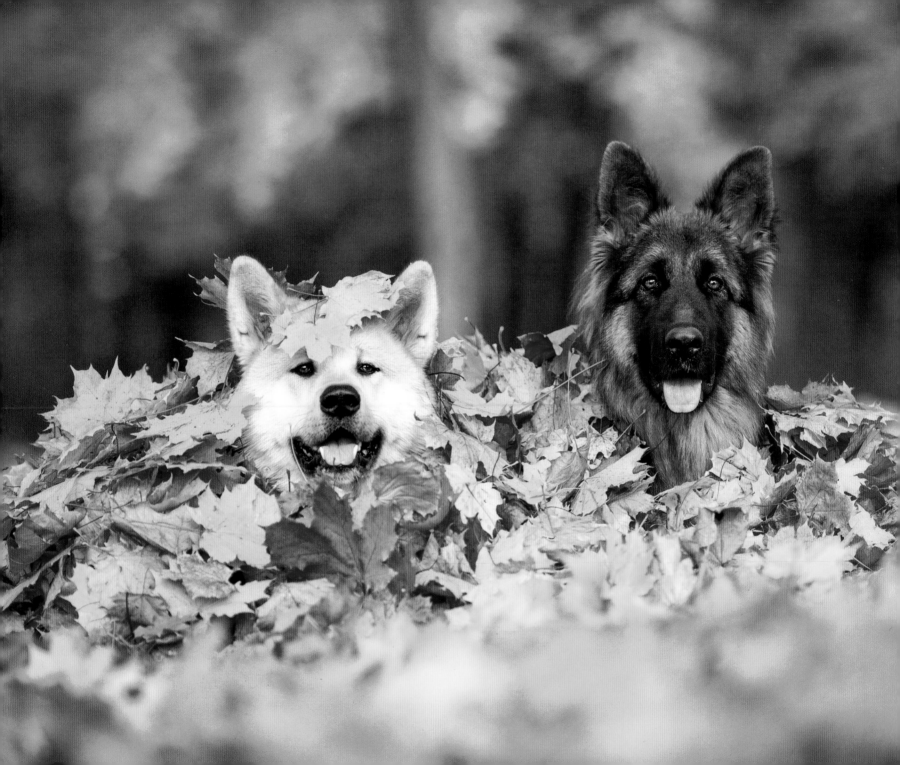

I BELIEVE IN AMERICA
BECAUSE WE HAVE GREAT DREAMS,
AND BECAUSE WE HAVE
THE OPPORTUNITY TO MAKE
THOSE DREAMS COME TRUE.

WENDELL WILLKIE

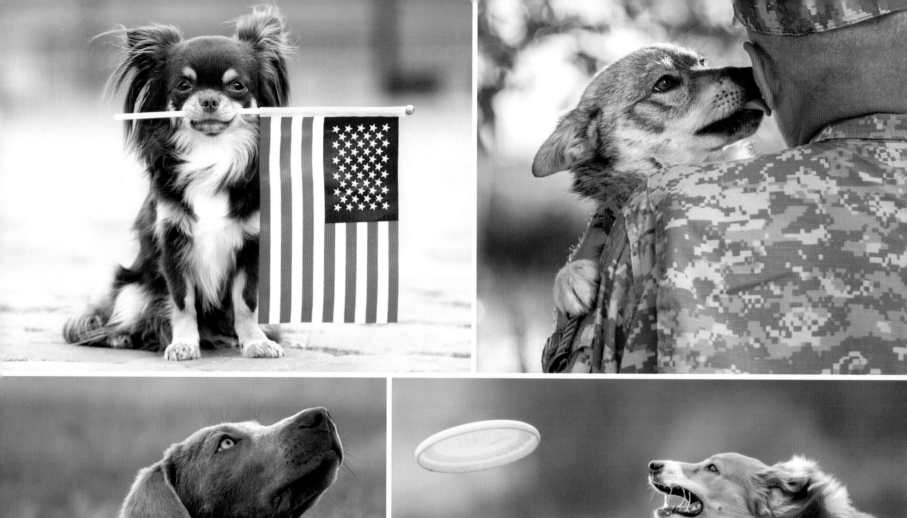
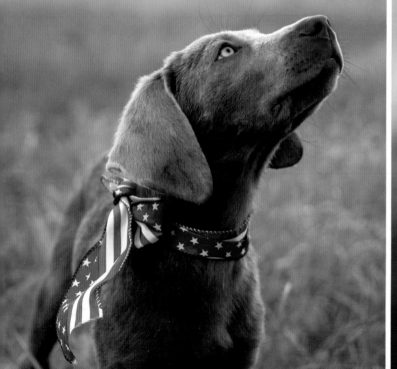
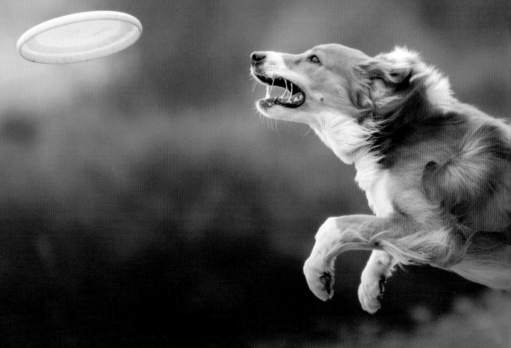

POOCHES
FOR
PATRIOTISM

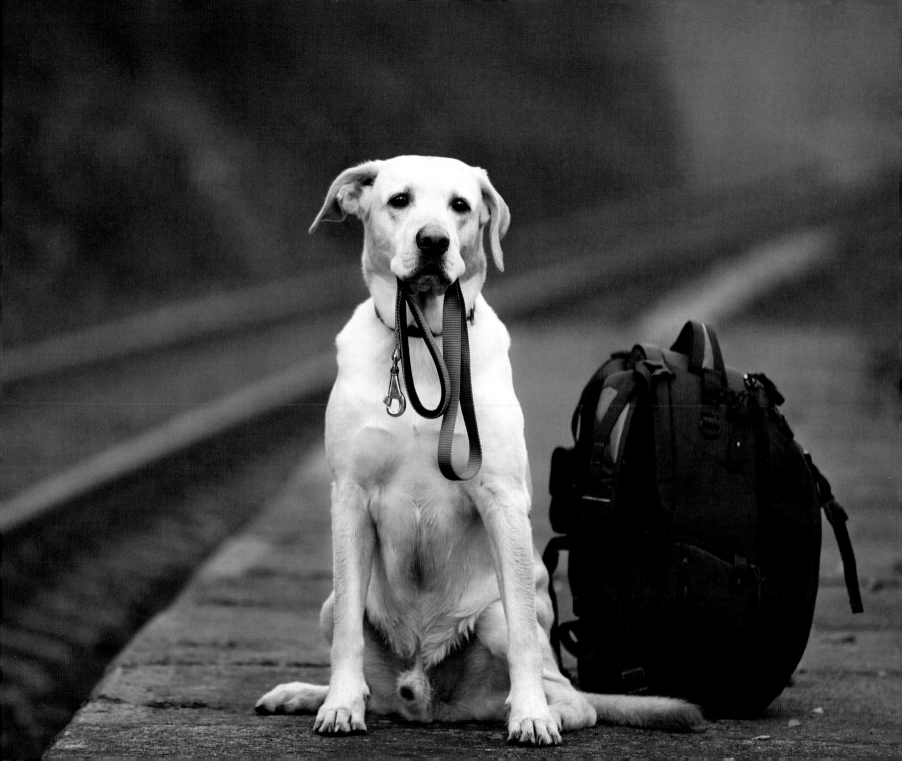

# THIS NATION WILL REMAIN THE LAND OF THE FREE ONLY SO LONG AS IT IS THE HOME OF THE BRAVE.

ELMER DAVIS

# COURAGE
## IS NOT THE ABSENCE
## OF FEAR, BUT
## THE CAPACITY TO ACT
## DESPITE OUR FEARS.

JOHN McCAIN

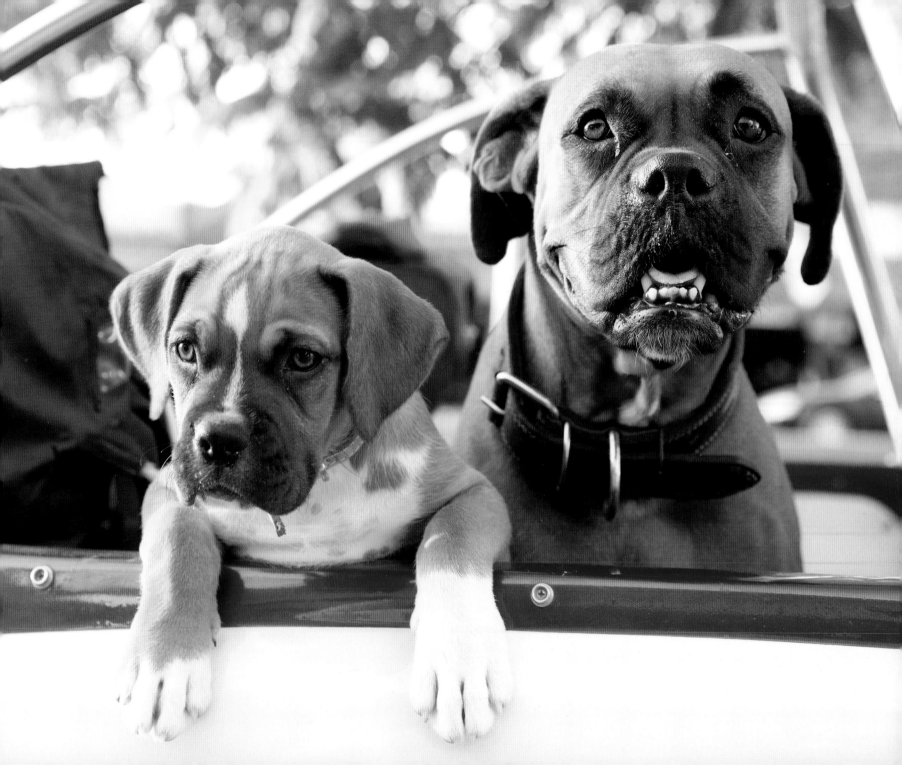

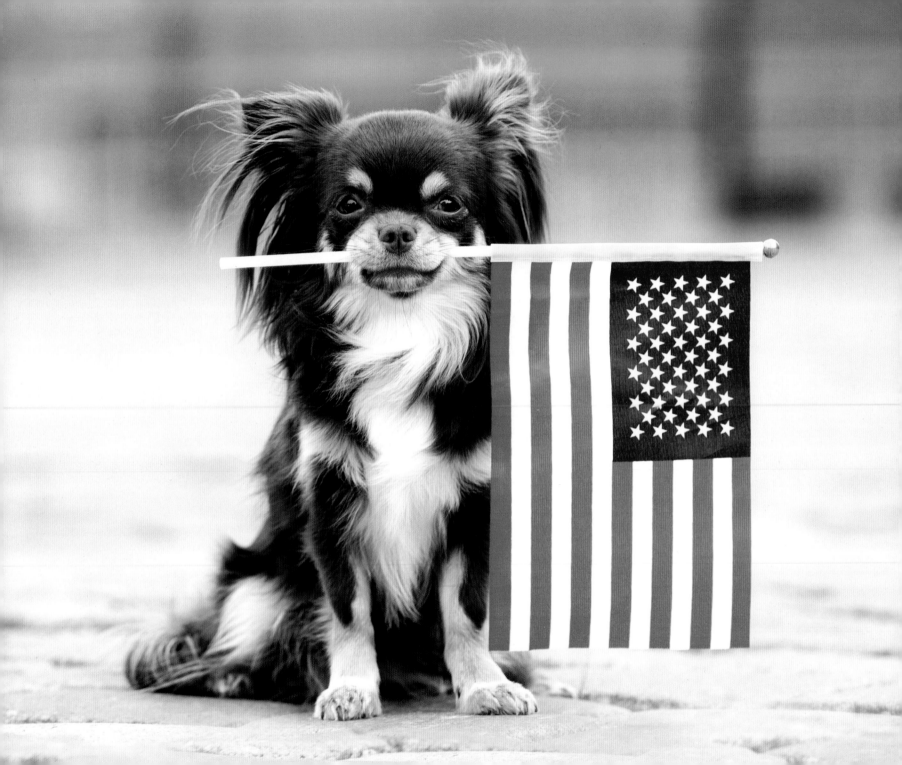

# WHEN THE WORLD LOOKS TO AMERICA, AMERICA LOOKS TO YOU, AND YOU NEVER LET HER DOWN.

HILLARY CLINTON

# PATRIOTISM IS NOT SHORT, FRENZIED OUTBURSTS OF EMOTION, BUT THE TRANQUIL AND STEADY DEDICATION OF A LIFETIME.

ADLAI E. STEVENSON

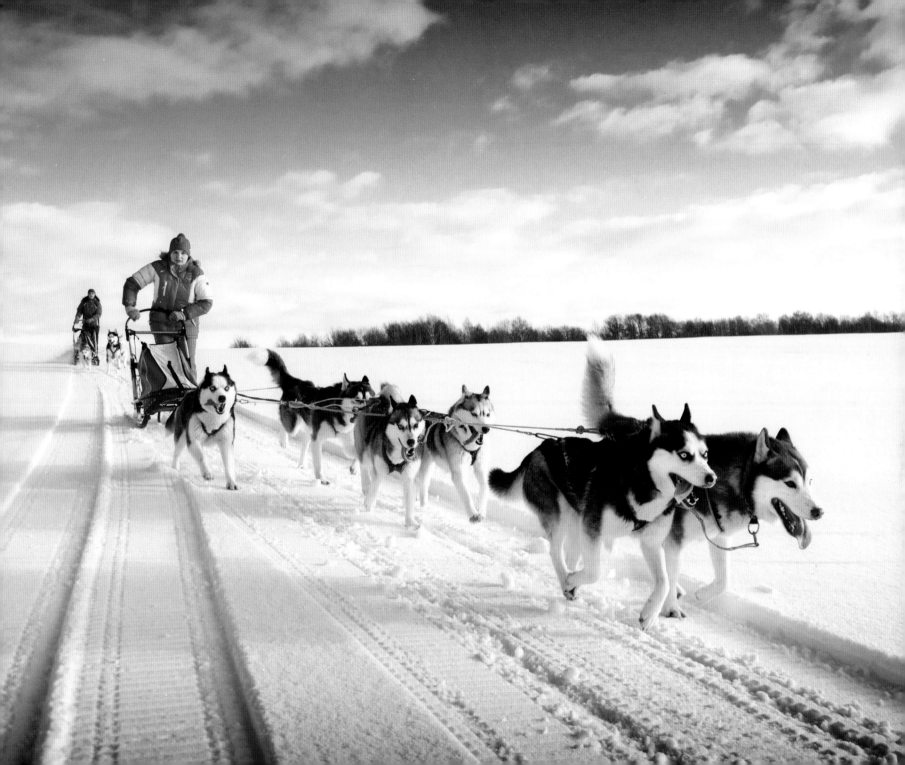

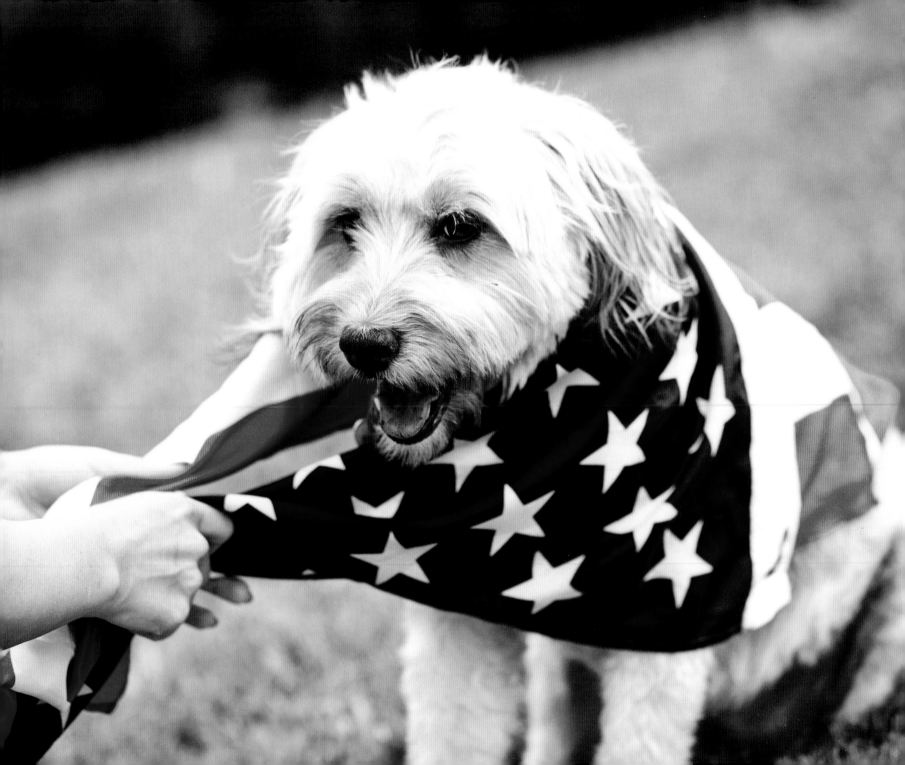

SO LET US SUMMON A NEW SPIRIT OF PATRIOTISM; OF SERVICE AND RESPONSIBILITY, WHERE EACH OF US RESOLVES TO PITCH IN AND WORK HARDER AND LOOK AFTER NOT ONLY OURSELVES, BUT EACH OTHER.

BARACK OBAMA

PATRIOTISM COMES FROM THE HEART.
PATRIOTISM IS VOLUNTARY. IT IS A FEELING
OF LOYALTY AND ALLEGIANCE THAT IS
THE RESULT OF KNOWLEDGE AND BELIEF.
A PATRIOT SHOWS THEIR PATRIOTISM
THROUGH THEIR ACTIONS, BY THEIR CHOICES.

JESSE VENTURA

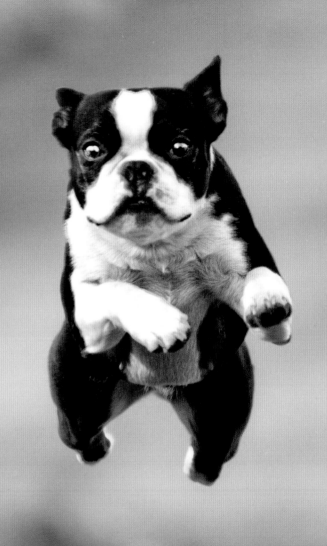

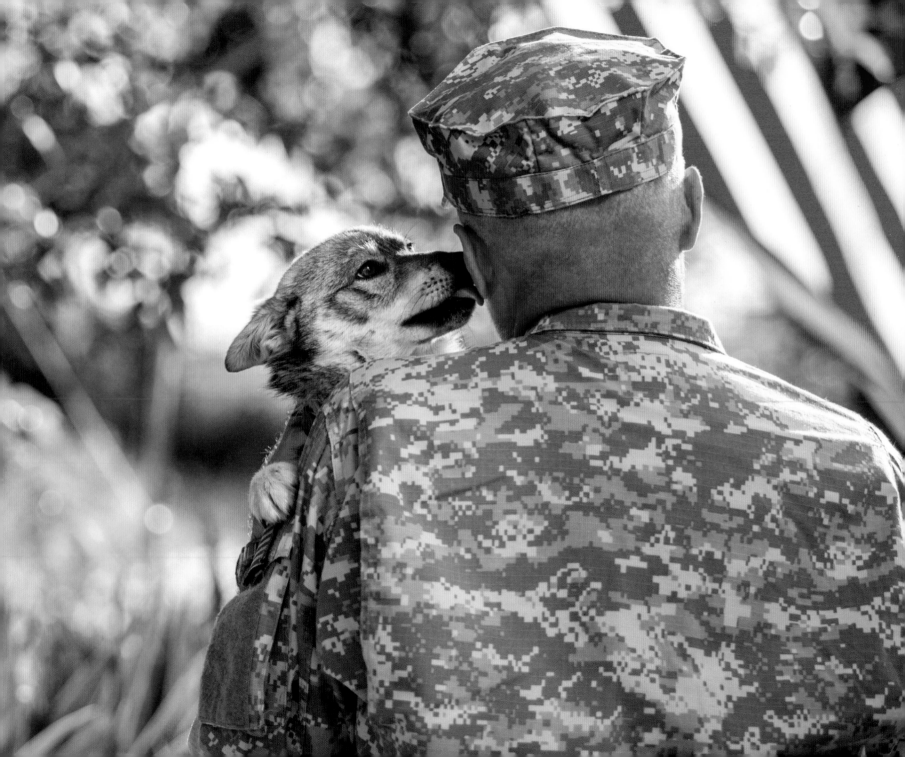

EVERY GOOD CITIZEN MAKES
HIS COUNTRY'S HONOR HIS OWN,
AND CHERISHES IT NOT ONLY
AS PRECIOUS BUT AS SACRED.

ANDREW JACKSON

# HE LOVES HIS COUNTRY BEST WHO STRIVES TO MAKE IT BEST.

ROBERT G. INGERSOLL

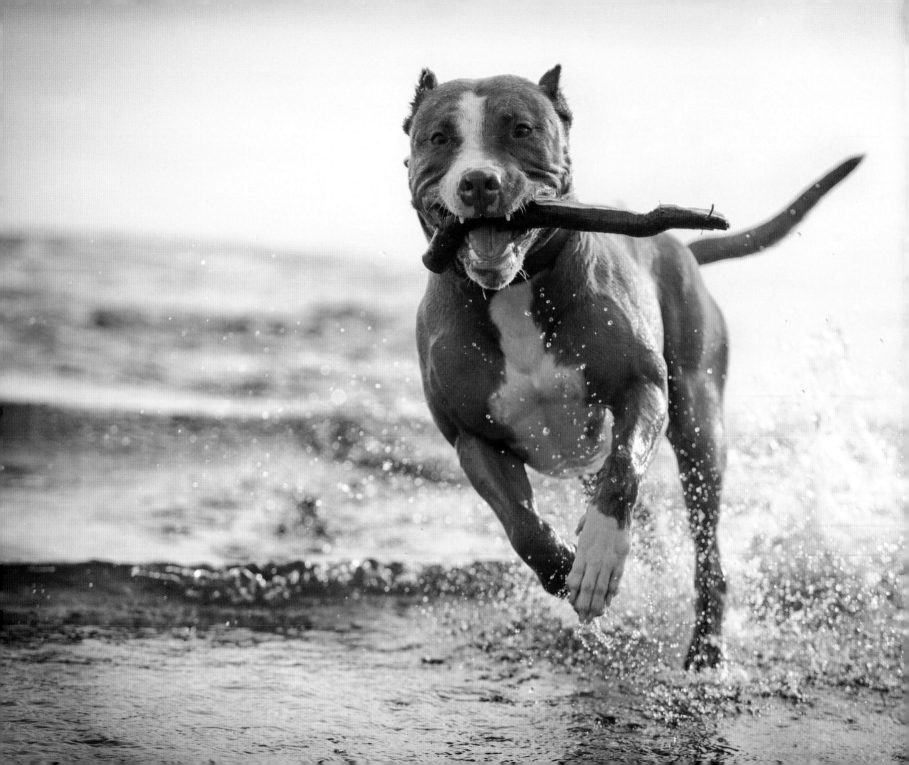

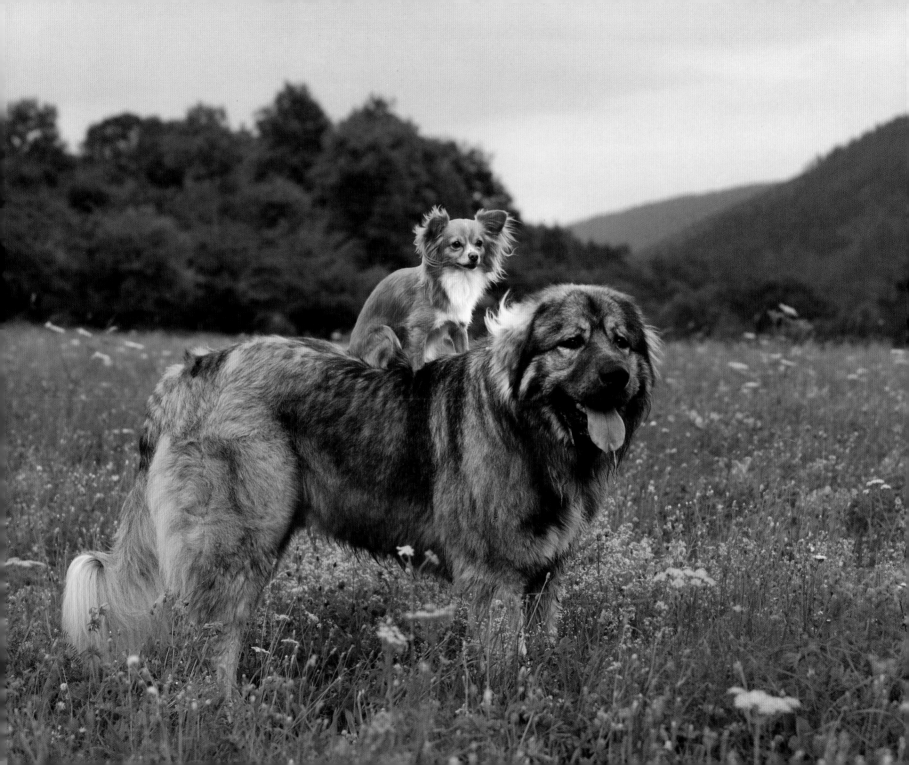

GLORY BELONGS
TO THE ACT OF BEING CONSTANT
TO SOMETHING GREATER THAN YOURSELF,
TO A CAUSE, TO YOUR PRINCIPLES,
TO THE PEOPLE ON WHOM YOU RELY
AND WHO RELY ON YOU.

JOHN McCAIN

# THE CONSTITUTION ONLY GIVES PEOPLE THE RIGHT TO PURSUE HAPPINESS. YOU HAVE TO CATCH IT YOURSELF.

BENJAMIN FRANKLIN

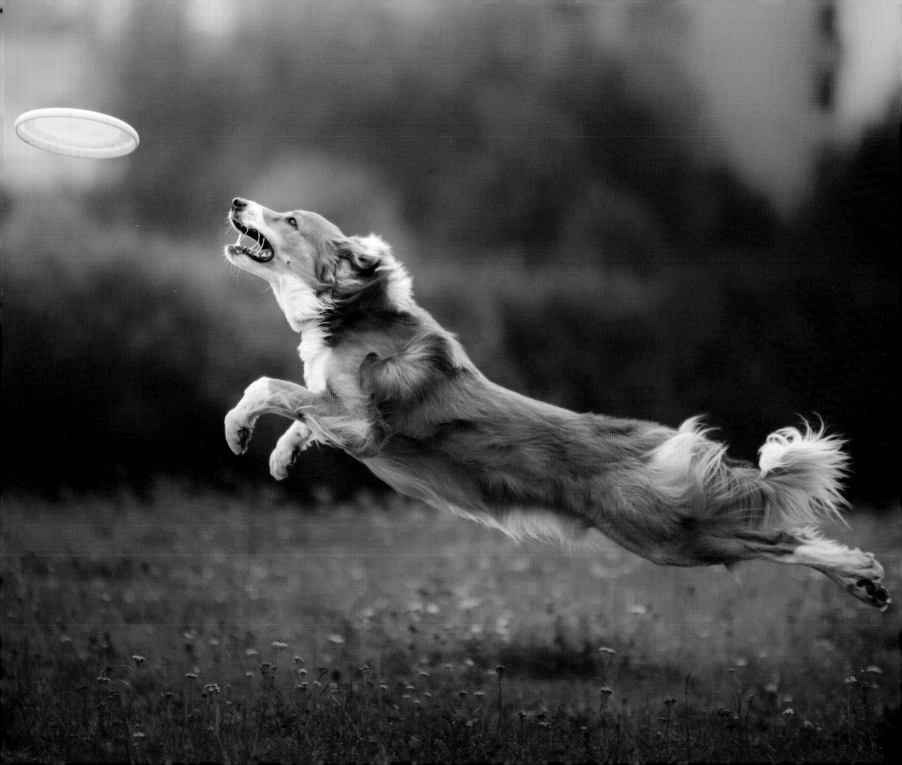

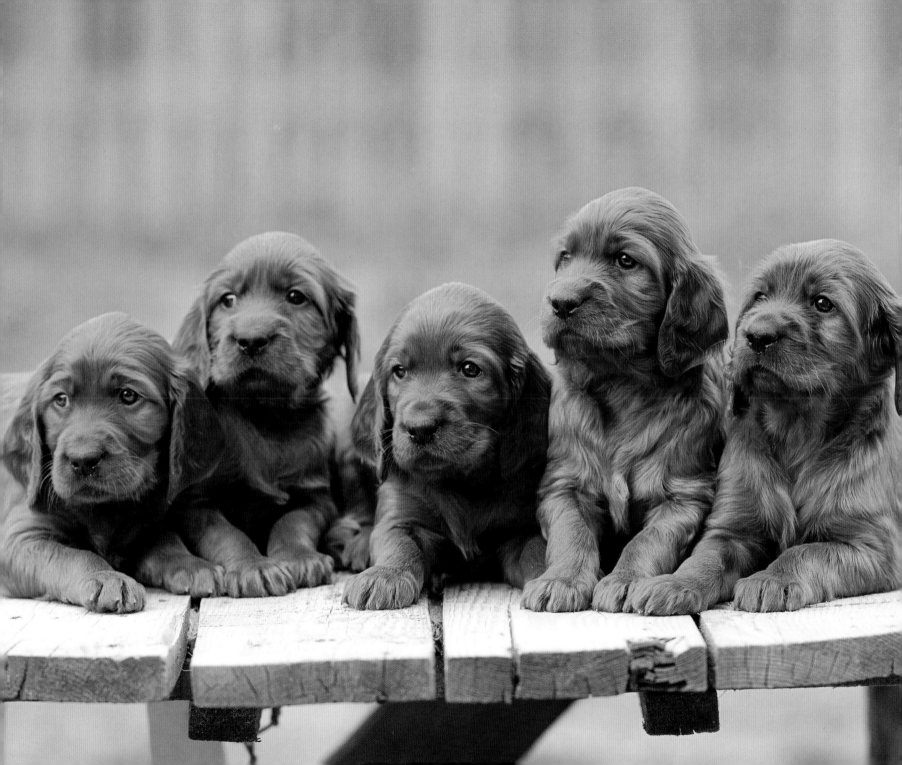

# WE CAN'T ALL BE WASHINGTONS, BUT WE CAN ALL BE PATRIOTS.

CHARLES F. BROWNE

TRUE PATRIOTISM
SPRINGS FROM A BELIEF IN THE
DIGNITY OF THE INDIVIDUAL,
FREEDOM AND EQUALITY
NOT ONLY FOR AMERICANS
BUT FOR ALL PEOPLE ON EARTH.

ELEANOR ROOSEVELT

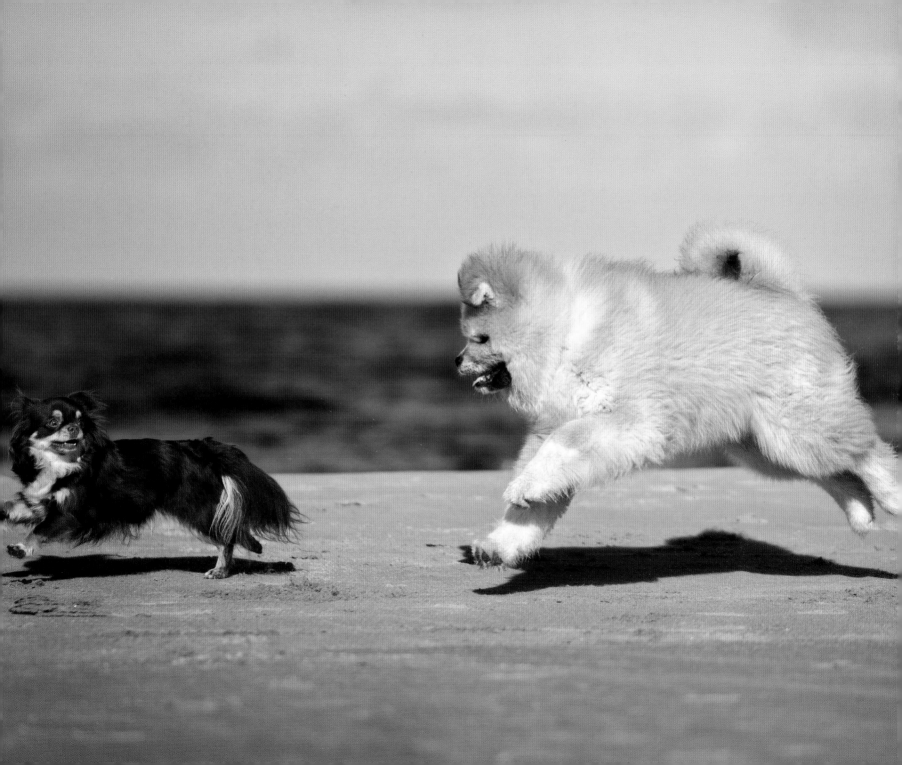

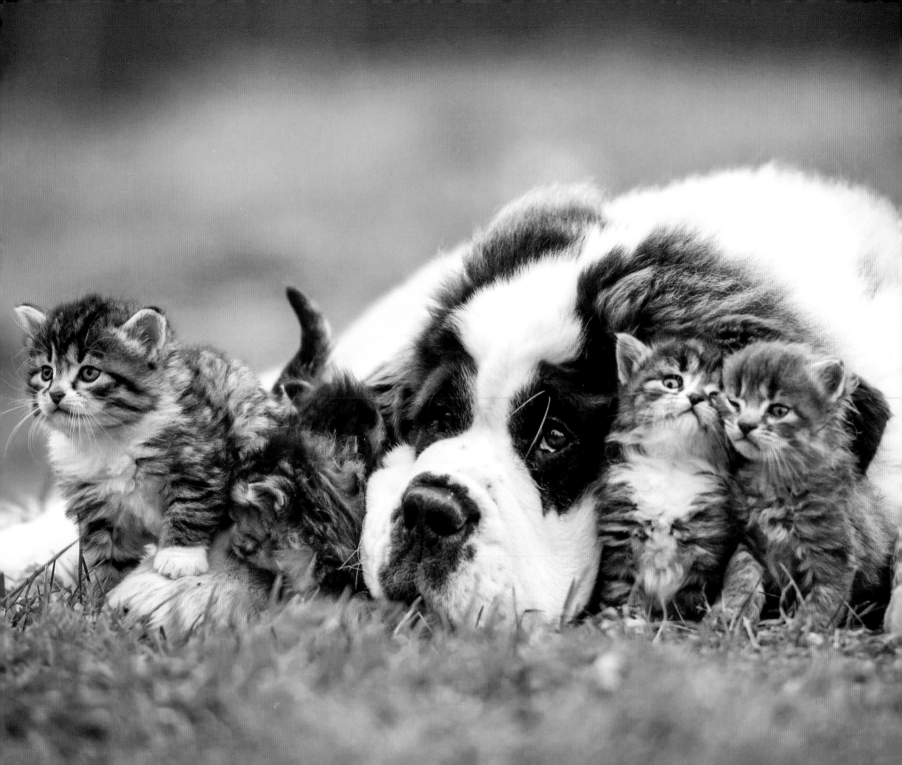

# DO WHAT YOU CAN, WITH WHAT YOU HAVE, WHERE YOU ARE.

THEODORE ROOSEVELT

# PATRIOTISM IS EASY TO UNDERSTAND IN AMERICA; IT MEANS LOOKING OUT FOR YOURSELF BY LOOKING OUT FOR YOUR COUNTRY.

CALVIN COOLIDGE

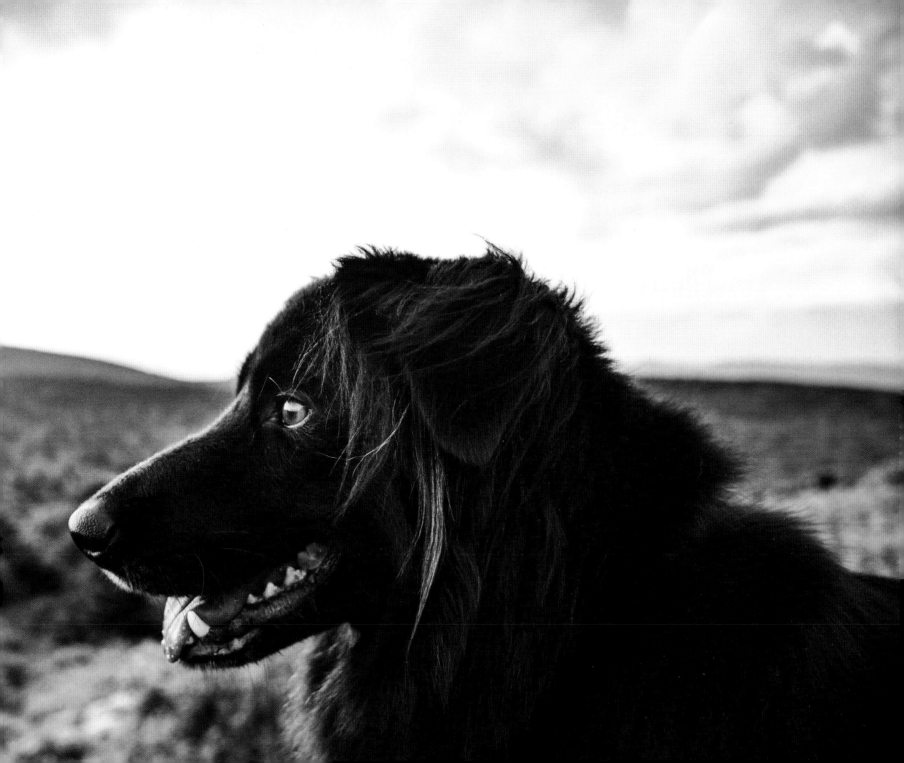

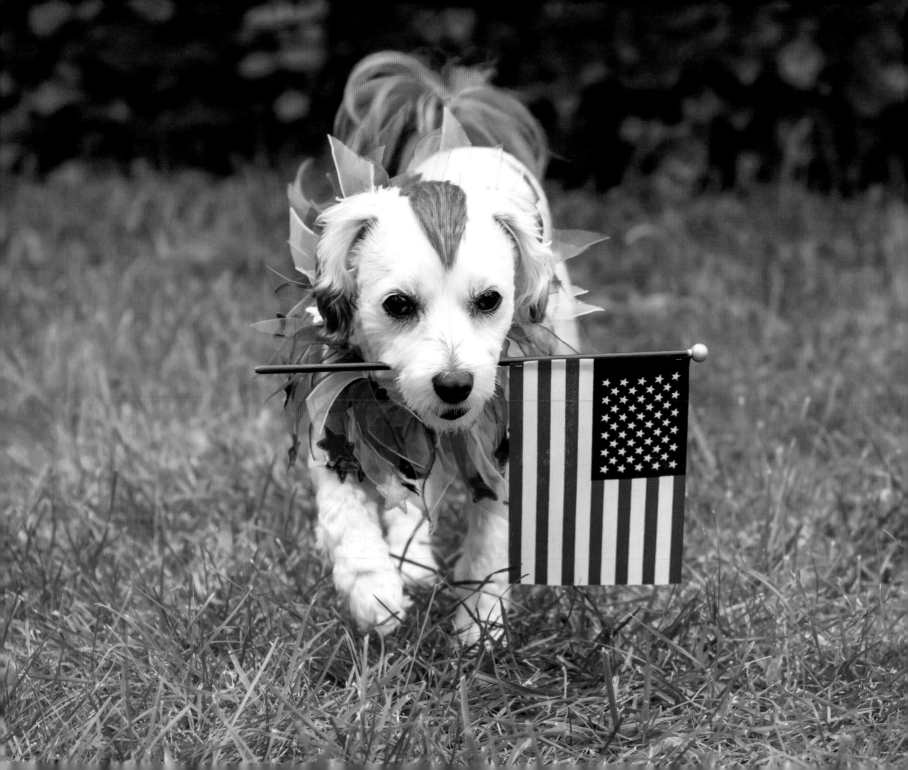

WHAT WE NEED ARE CRITICAL LOVERS
OF AMERICA—PATRIOTS
WHO EXPRESS THEIR FAITH
IN THEIR COUNTRY
BY WORKING TO IMPROVE IT.

HUBERT HUMPHREY

# I THINK PATRIOTISM IS LIKE CHARITY— IT BEGINS AT HOME.

HENRY JAMES

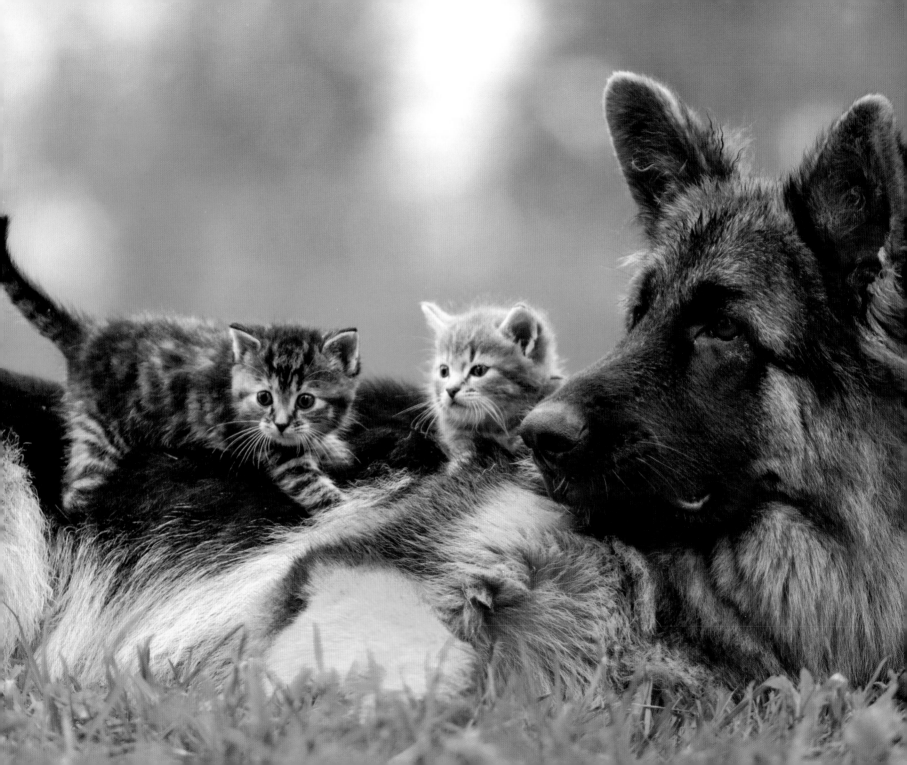

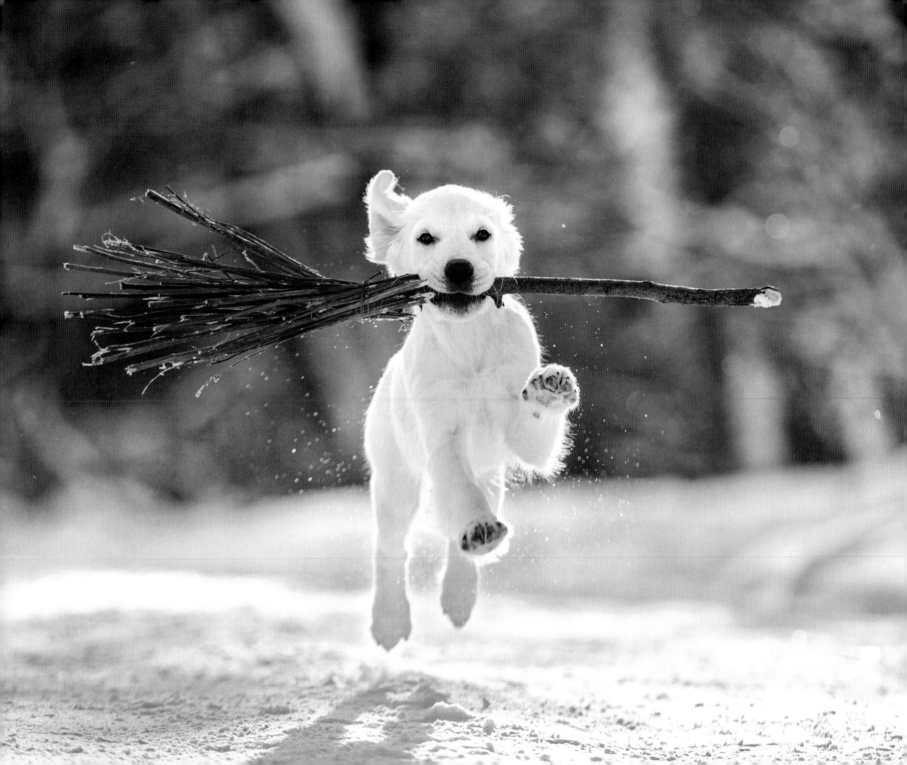

WE ARE A NATION NOT ONLY OF DREAMERS,
BUT ALSO OF FIXERS.
WE HAVE LOOKED AT OUR LAND AND PEOPLE,
AND SAID, TIME AND TIME AGAIN,
"THIS IS NOT GOOD ENOUGH;
WE CAN BE BETTER."

DAN RATHER

# PATRIOTISM CONSISTS NOT IN WAVING THE FLAG, BUT IN STRIVING THAT OUR COUNTRY SHALL BE RIGHTEOUS AS WELL AS STRONG.

JAMES BRYCE

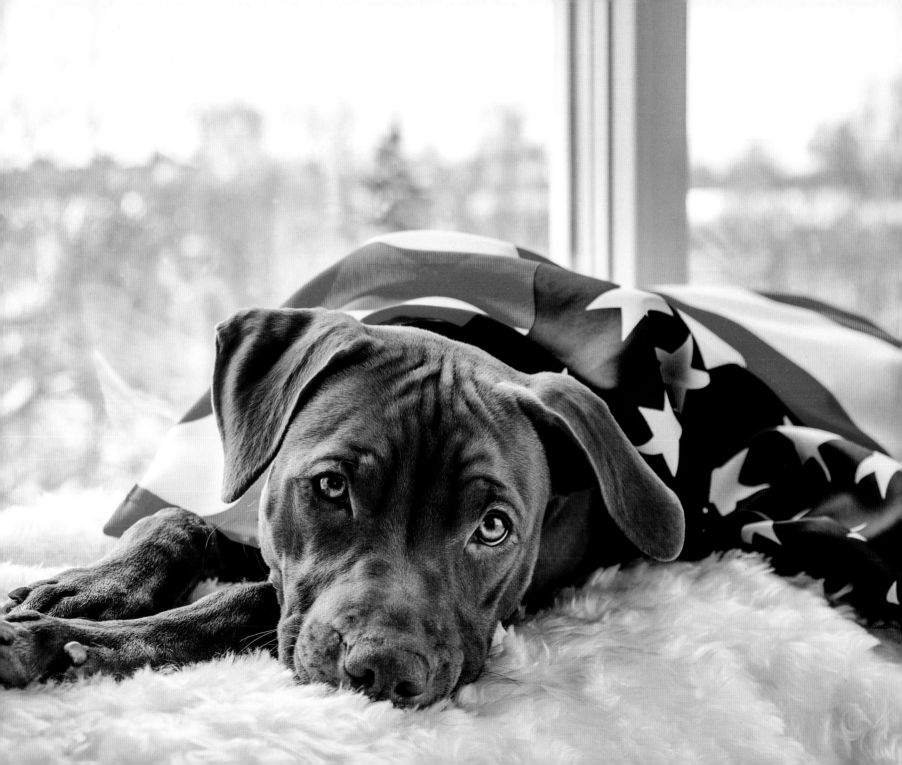

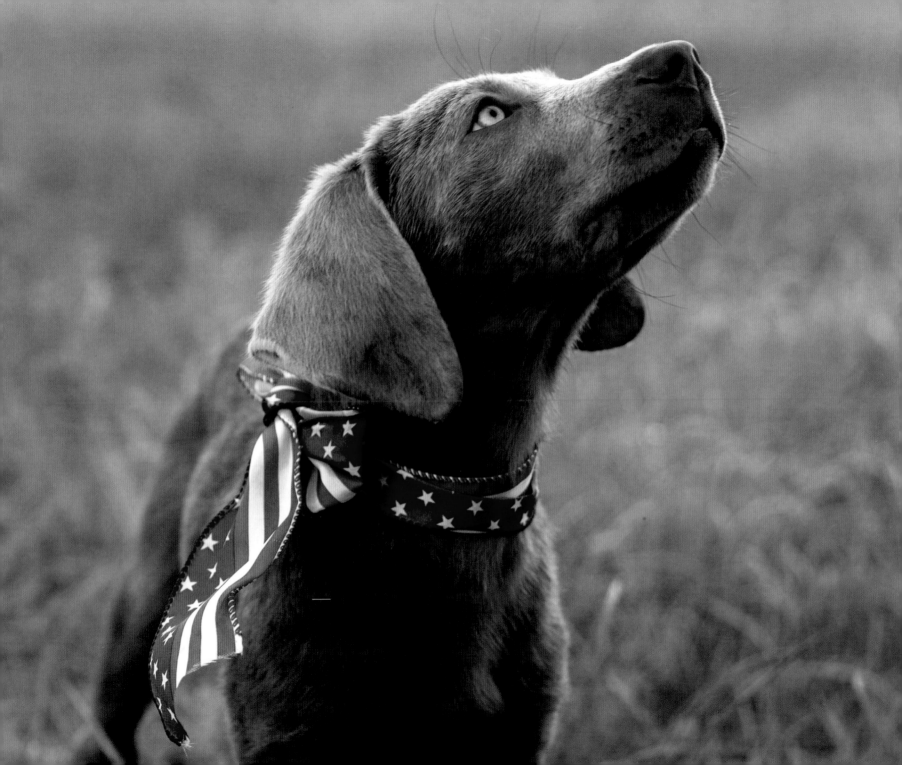

# THE LIFE OF THE NATION IS SECURE ONLY WHILE THE NATION IS HONEST, TRUTHFUL, AND VIRTUOUS.

FREDERICK DOUGLASS

# THE HIGHEST PATRIOTISM
## IS NOT A BLIND ACCEPTANCE
## OF OFFICIAL POLICY,
# BUT A LOVE OF ONE'S COUNTRY
# DEEP ENOUGH TO CALL HER
# TO A HIGHER PLAIN.

GEORGE McGOVERN

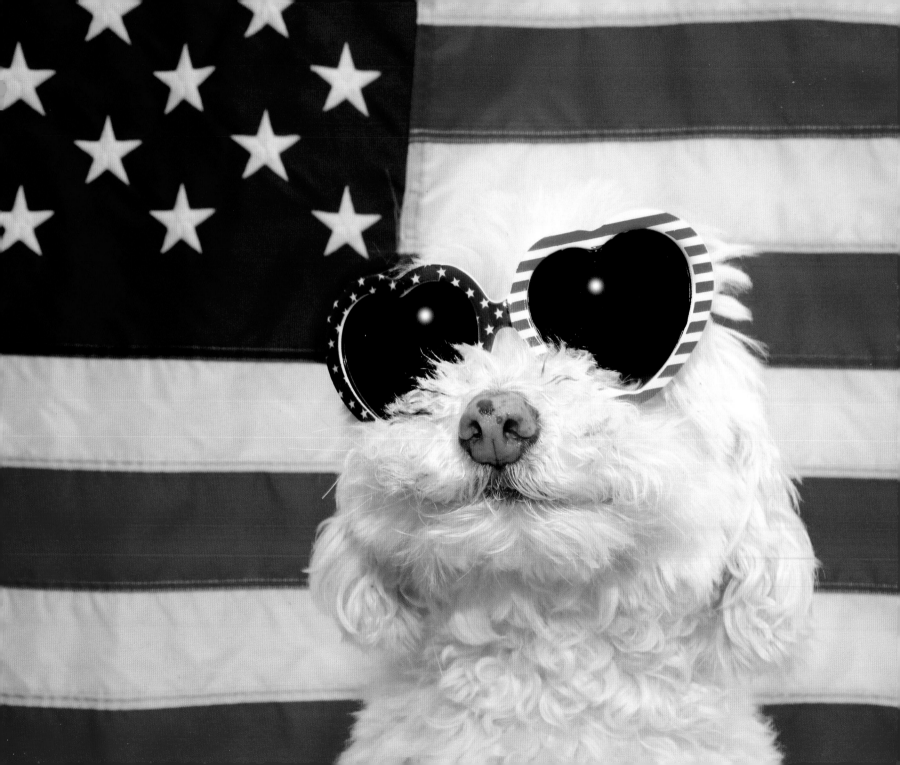

MY DREAM IS OF
A PLACE AND A TIME WHERE
AMERICA WILL ONCE AGAIN BE SEEN AS
THE LAST BEST HOPE OF EARTH.

ABRAHAM LINCOLN

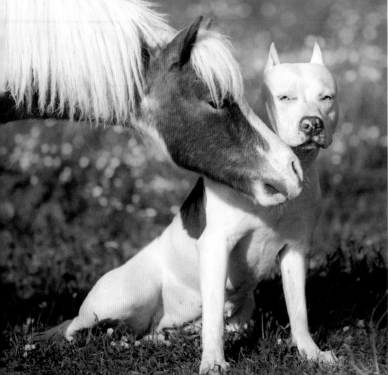
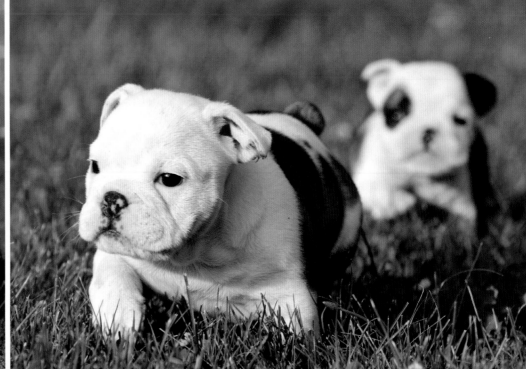

AMERICA'S BEST FRIENDS IN UNITY

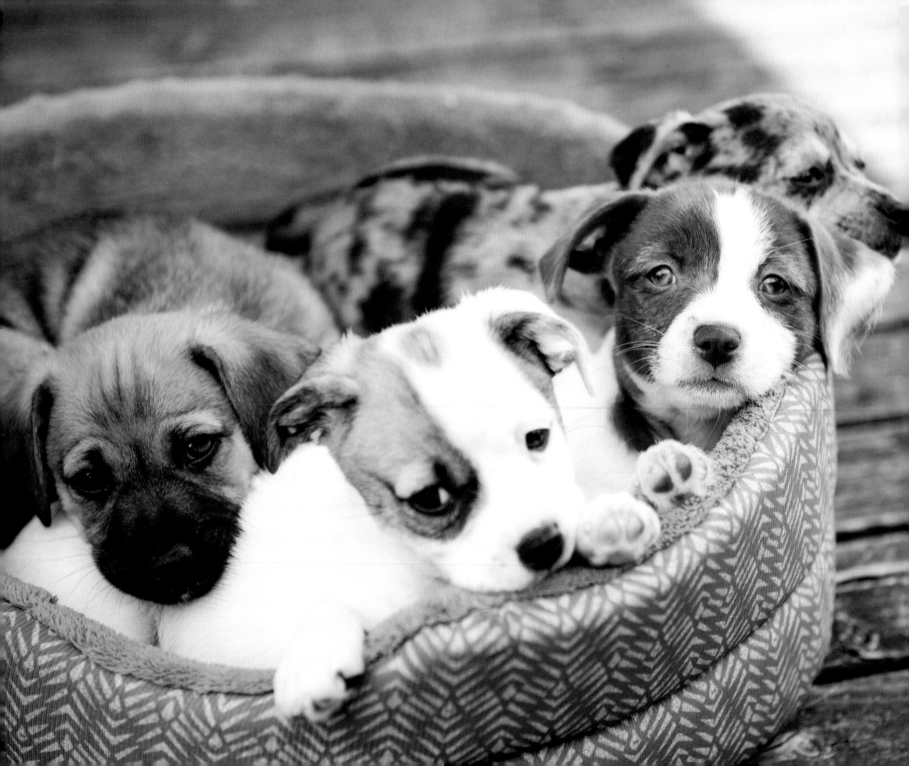

# AMERICA IS NOT ANYTHING IF IT CONSISTS OF EACH OF US. IT IS SOMETHING ONLY IF IT CONSISTS OF ALL OF US.

WOODROW WILSON

# AMERICA IS A TUNE.
## IT MUST BE SUNG TOGETHER.

GERALD STANLEY LEE

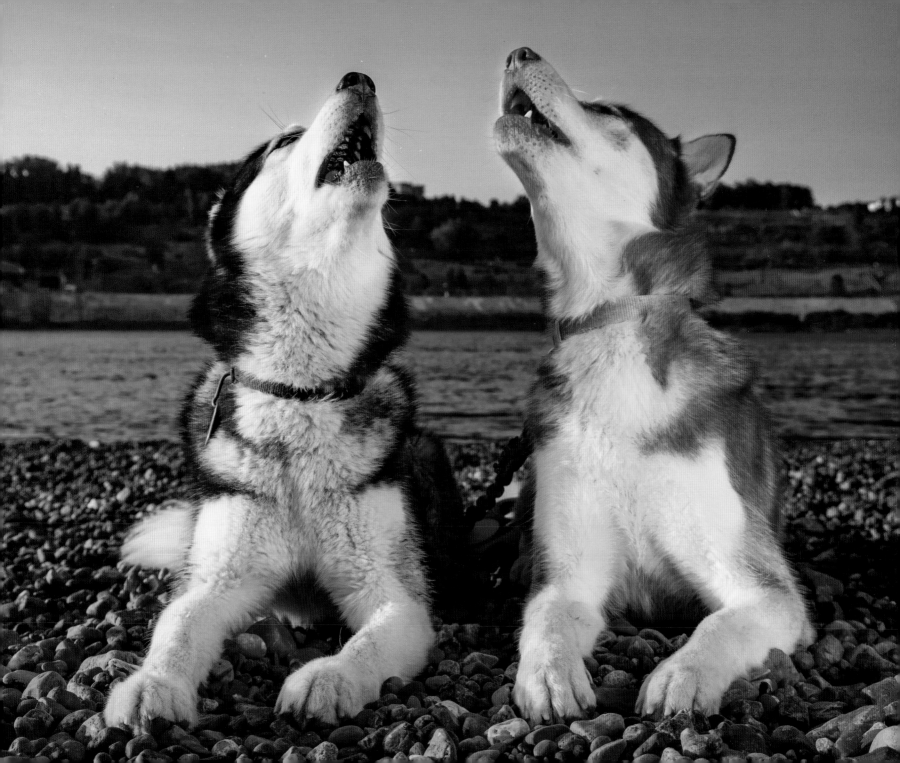

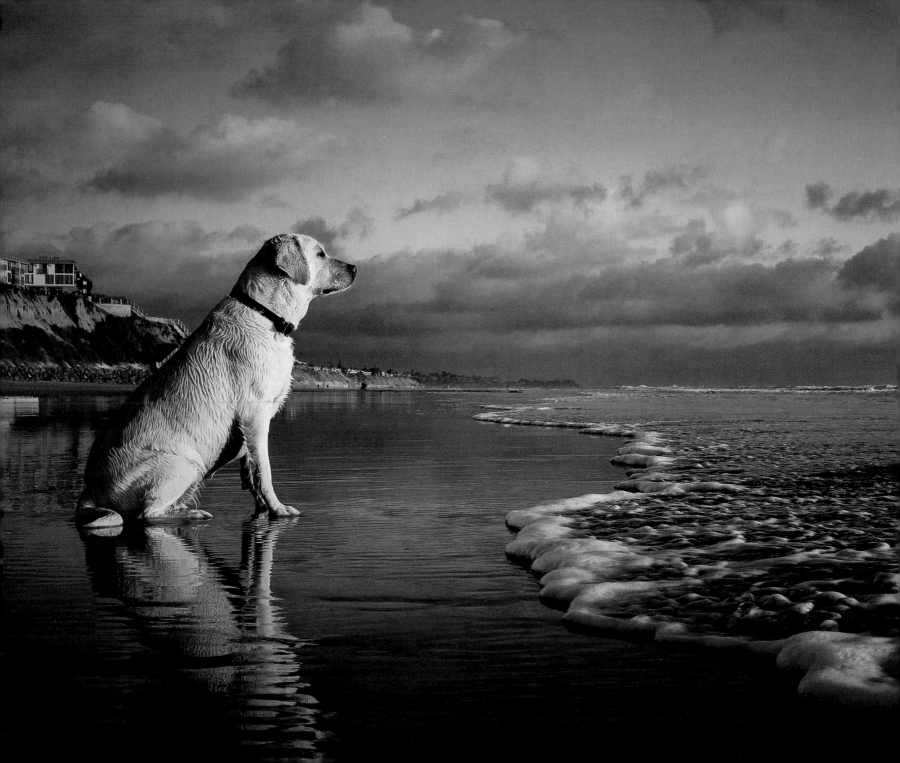

# UNITY OF FREEDOM HAS NEVER RELIED ON UNIFORMITY OF OPINION.

JOHN F. KENNEDY

WE CANNOT BE SEPARATED
IN INTEREST OR DIVIDED IN PURPOSE.
WE STAND TOGETHER
UNTIL THE END.

WOODROW WILSON

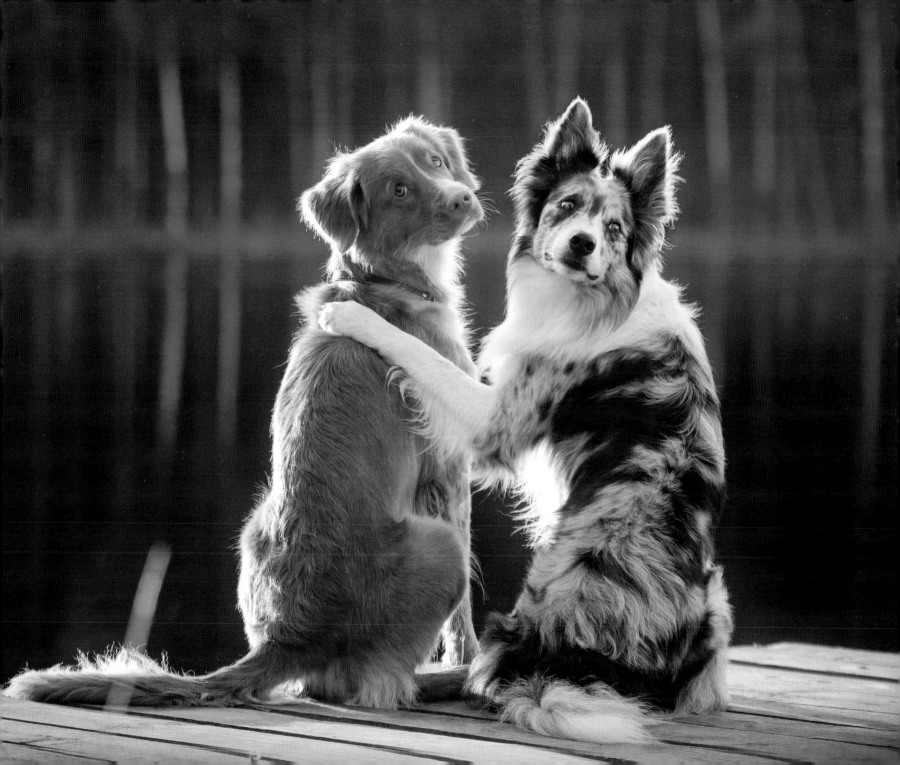

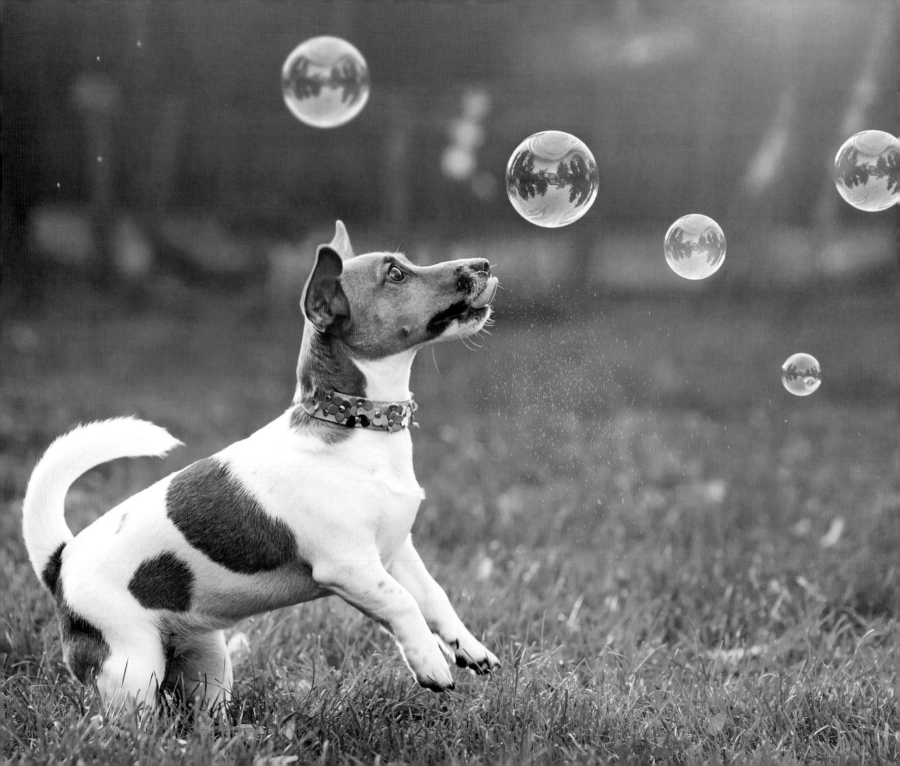

WE MAY COME FROM
DIFFERENT PLACES AND
HAVE DIFFERENT STORIES,
BUT WE SHARE COMMON HOPES,
AND ONE VERY AMERICAN DREAM.

BARACK OBAMA

# ULTIMATELY, AMERICA'S ANSWER TO THE INTOLERANT MAN IS DIVERSITY, THE VERY DIVERSITY WHICH OUR HERITAGE OF RELIGIOUS FREEDOM HAS INSPIRED.

ROBERT F. KENNEDY

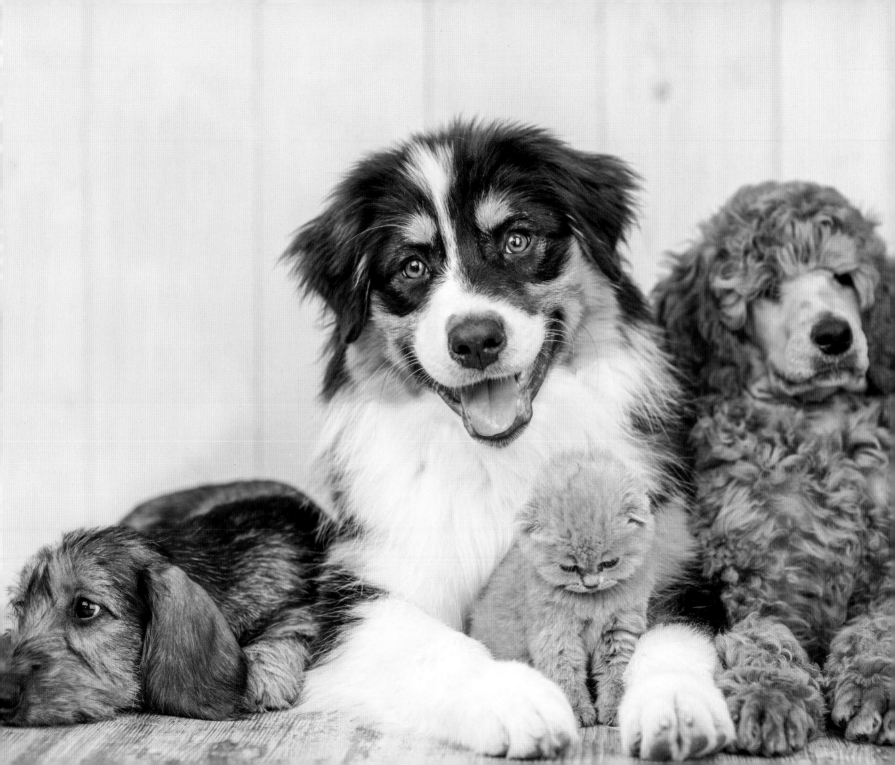

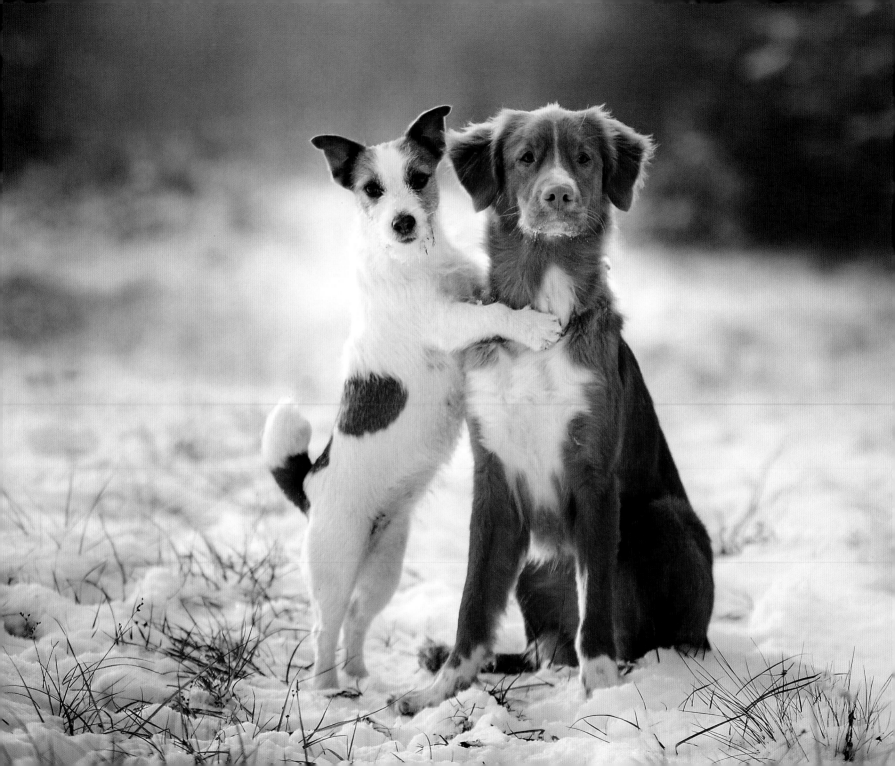

# THIS COUNTRY
## WILL NOT BE A GOOD PLACE
## FOR ANY OF US TO LIVE IN UNLESS
## WE MAKE IT A GOOD PLACE FOR
## ALL OF US TO LIVE IN.

THEODORE ROOSEVELT

# ONE FLAG, ONE LAND, ONE HEART, ONE HAND, ONE NATION EVERMORE!

OLIVER WENDELL HOLMES

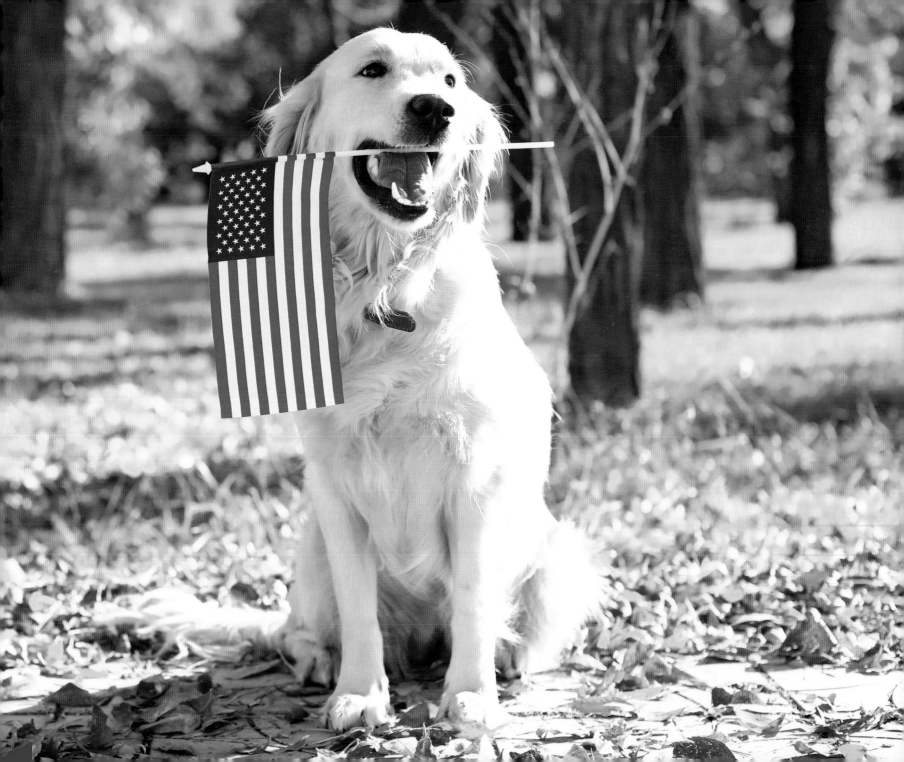

THE FACT IS, WITH
EVERY FRIENDSHIP YOU MAKE, AND
EVERY BOND OF TRUST YOU ESTABLISH,
YOU ARE SHAPING THE IMAGE
OF AMERICA PROJECTED
TO THE REST OF THE WORLD.

MICHELLE OBAMA

THE LAND FLOURISHED
BECAUSE IT WAS FED FROM
SO MANY SOURCES—BECAUSE IT WAS
NOURISHED BY SO MANY
CULTURES AND TRADITIONS AND PEOPLES.

LYNDON B. JOHNSON

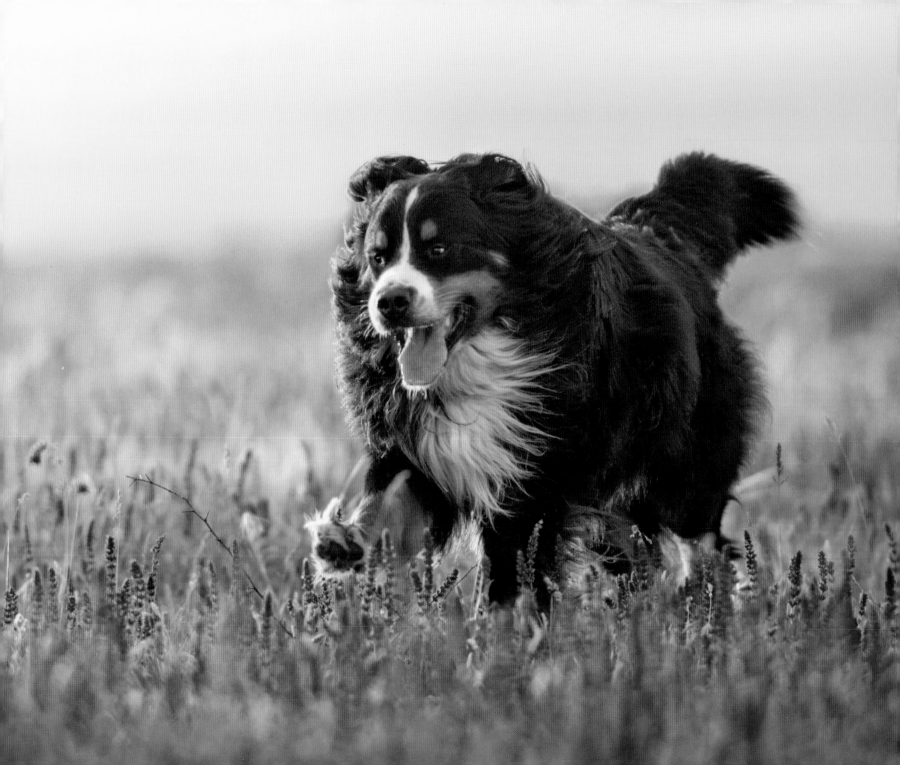

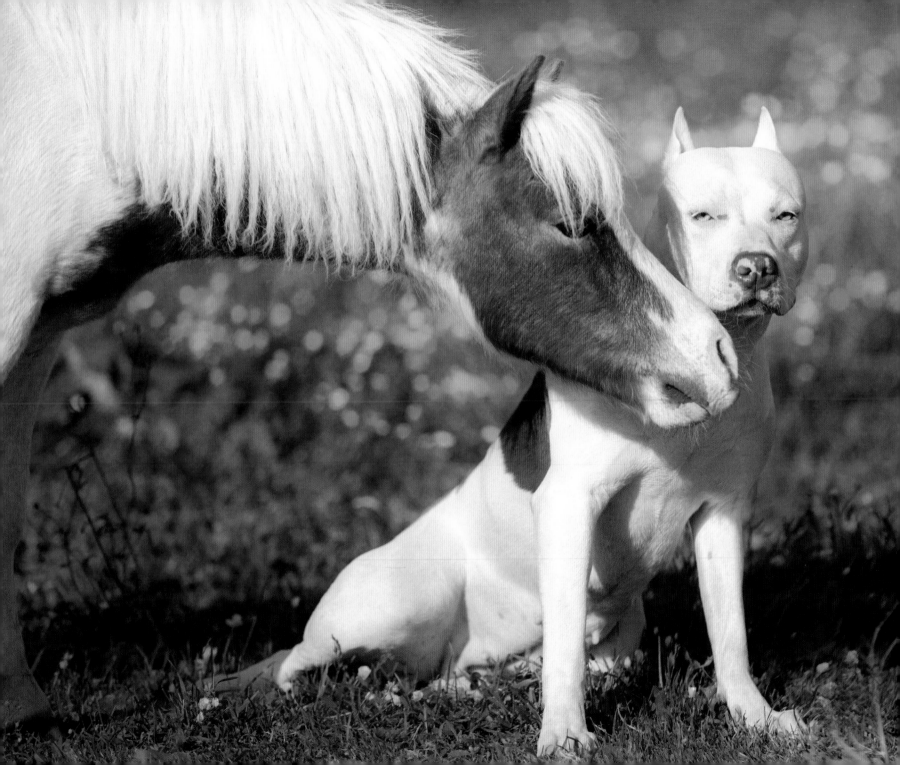

# IN DIVERSITY
## THERE IS
## BEAUTY
## AND THERE IS
## STRENGTH.

MAYA ANGELOU

THE MAGIC OF AMERICA IS THAT WE'RE A FREE AND OPEN SOCIETY WITH A MIXED POPULATION. PART OF OUR SECURITY IS OUR FREEDOM.

MADELEINE ALBRIGHT

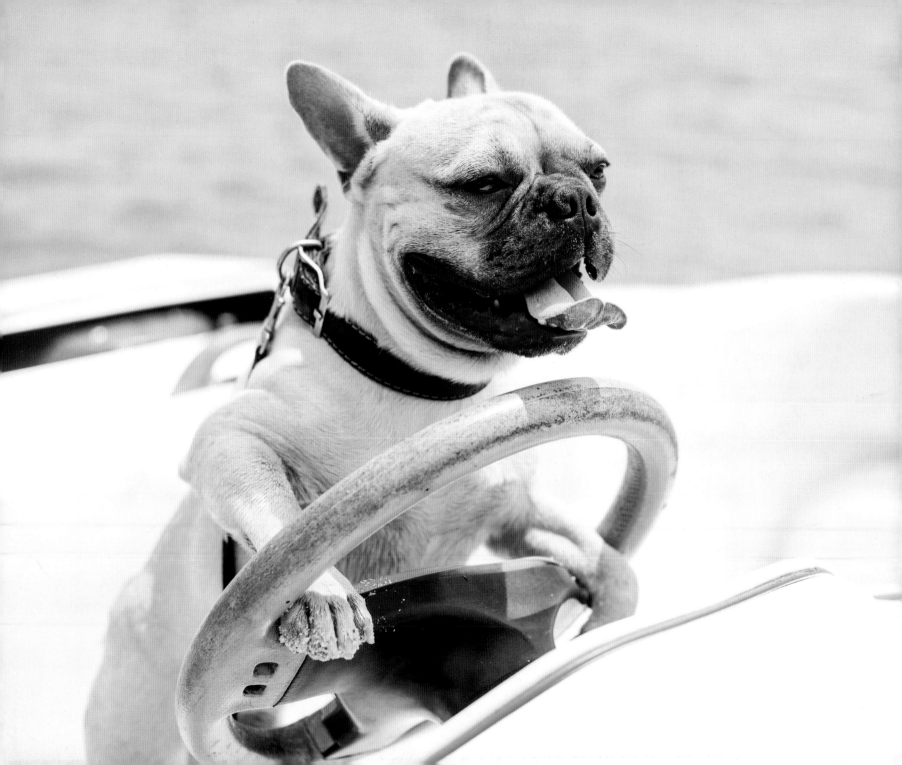

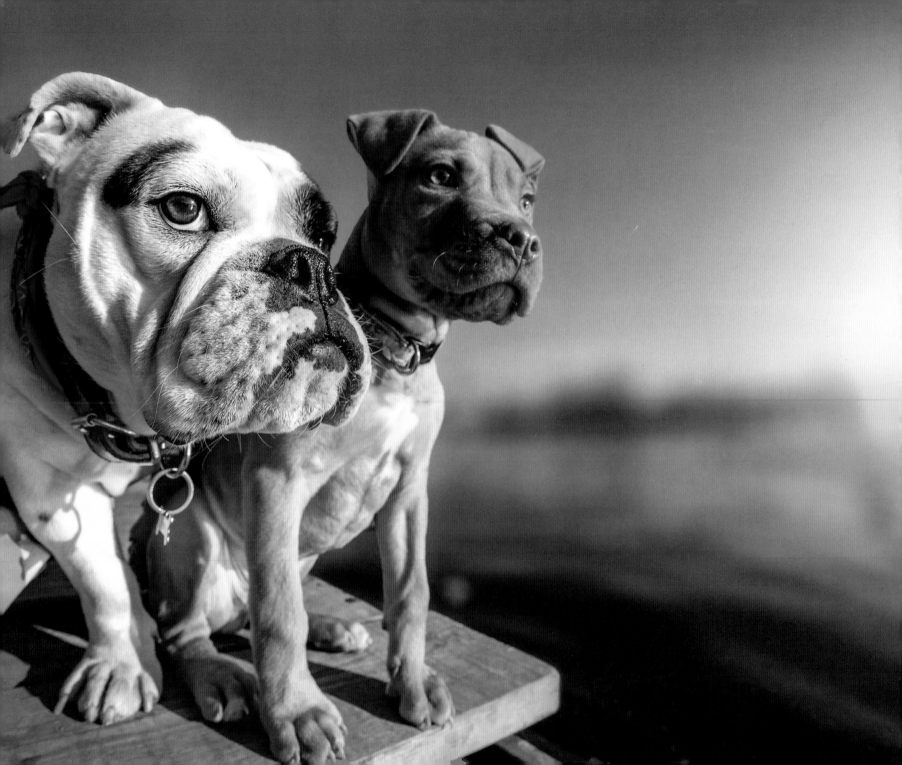

WE DIDN'T RAISE
THE STATUE OF LIBERTY
WITH HER BACK TO THE WORLD,
WE DID IT WITH
HER LIGHT SHINING AS A BEACON
TO THE WORLD.

BARACK OBAMA

IN AMERICA IT DOESN'T MATTER
WHERE YOU CAME FROM,
IT MATTERS
WHERE YOU ARE GOING.

CONDOLEEZA RICE

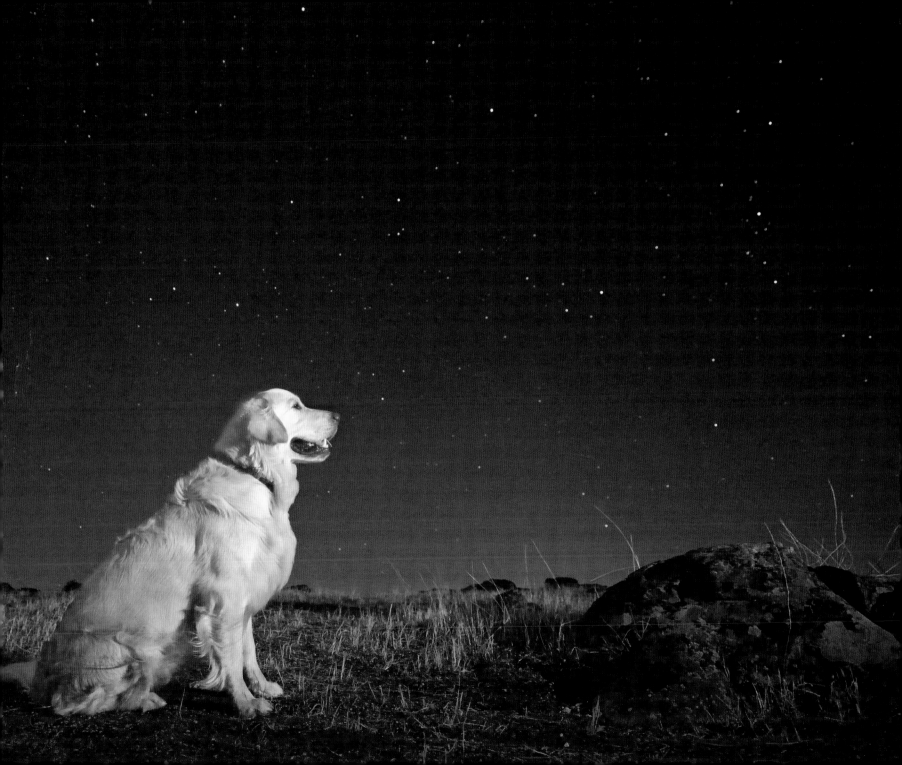

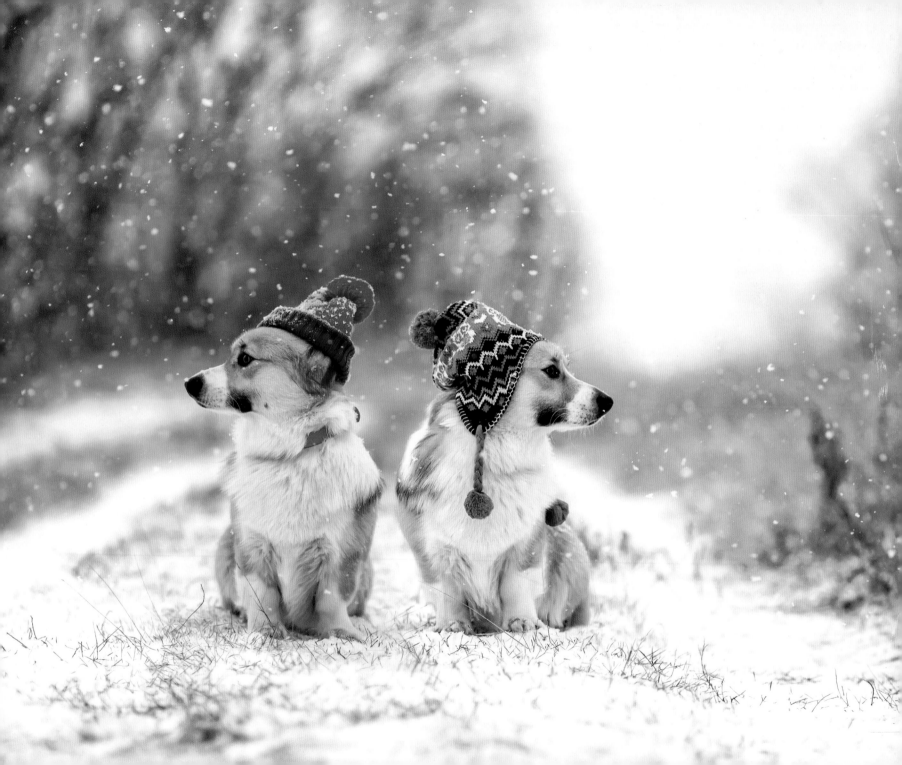

# THIS IS AMERICA: A BRILLIANT DIVERSITY SPREAD LIKE STARS, LIKE A THOUSAND POINTS OF LIGHT, IN A BROAD AND PEACEFUL SKY.

GEORGE H.W. BUSH

EVERY AMERICAN CARRIES
IN HIS BLOODSTREAM
THE HERITAGE
OF THE MALCONTENT
AND THE DREAMER.

DOROTHY FULDHEIM

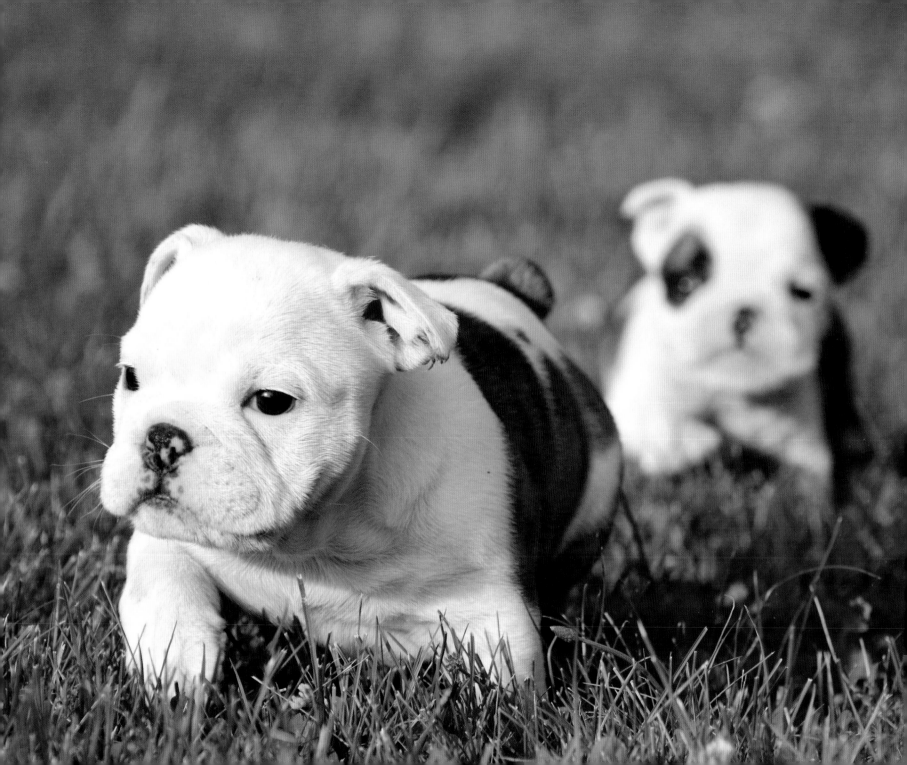

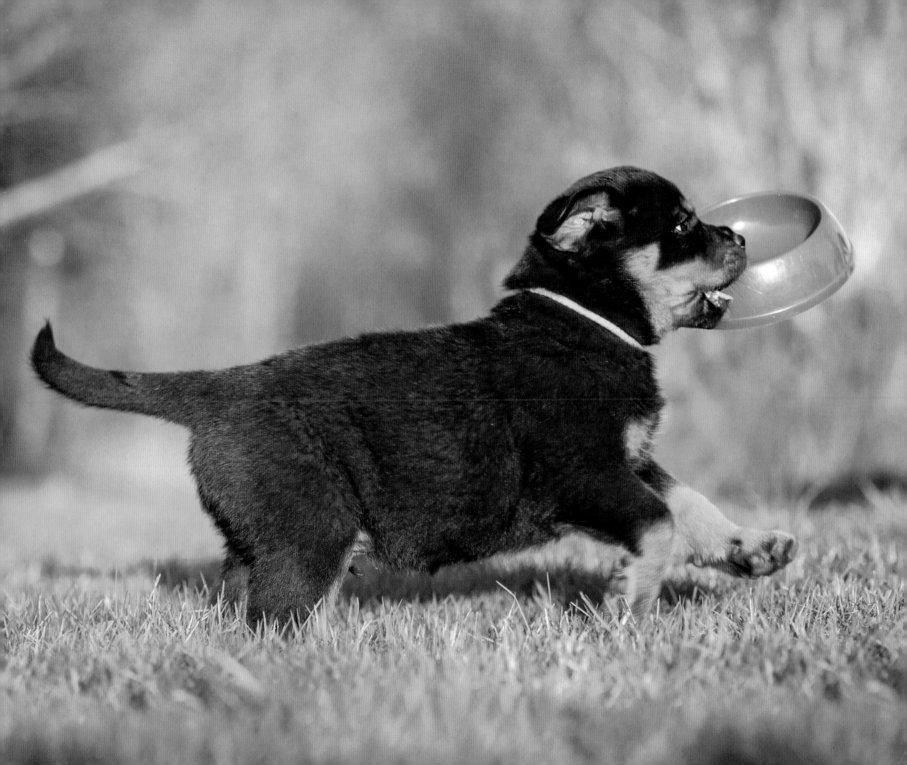

WHILE MEN INHABITING DIFFERENT PARTS OF THIS VAST CONTINENT CANNOT BE EXPECTED TO HOLD THE SAME OPINIONS, THEY CAN UNITE IN A COMMON OBJECTIVE AND SUSTAIN COMMON PRINCIPLES.

FRANKLIN PIERCE

# WHEN WE STAND TOGETHER THERE IS NOTHING, NOTHING, NOTHING WE CANNOT ACCOMPLISH.

BERNIE SANDERS

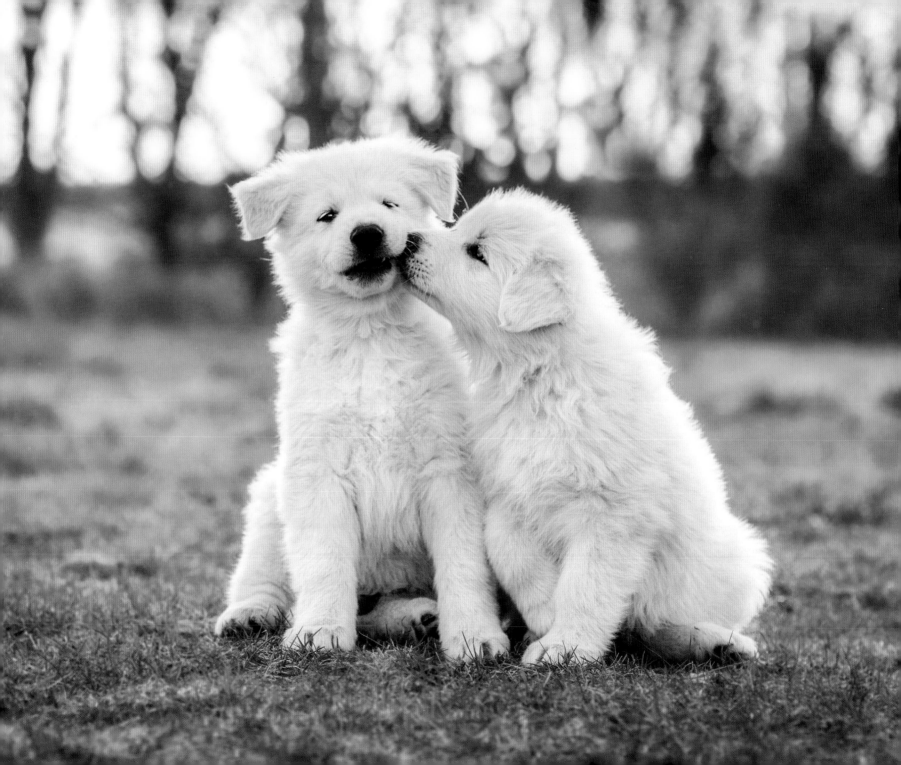

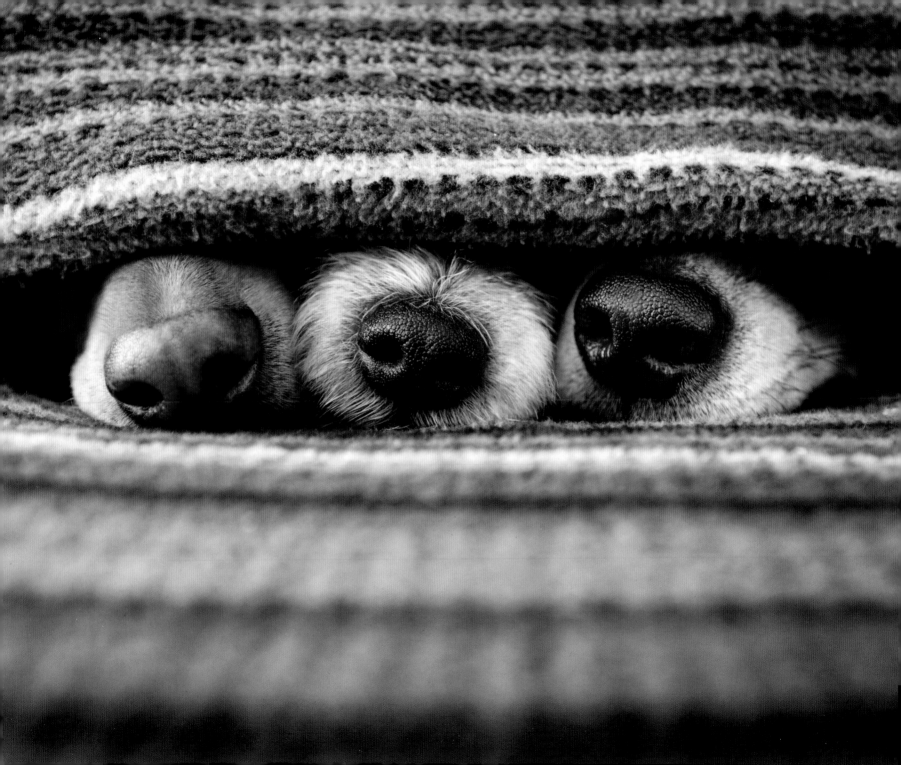

GOVERNMENT
OF THE PEOPLE,
BY THE PEOPLE, FOR THE PEOPLE,
SHALL NOT PERISH
FROM THE EARTH.

ABRAHAM LINCOLN

WE HAVE BECOME NOT A MELTING POT
BUT A BEAUTIFUL MOSAIC.
DIFFERENT PEOPLE, DIFFERENT BELIEFS,
DIFFERENT YEARNINGS, DIFFERENT HOPES,
DIFFERENT DREAMS.

JIMMY CARTER

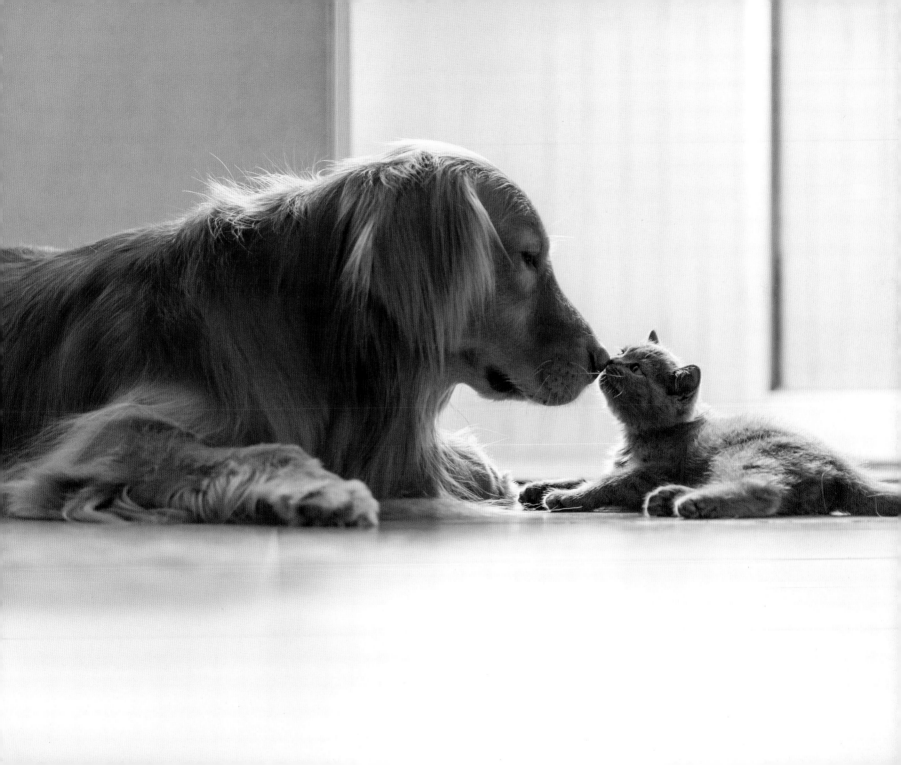

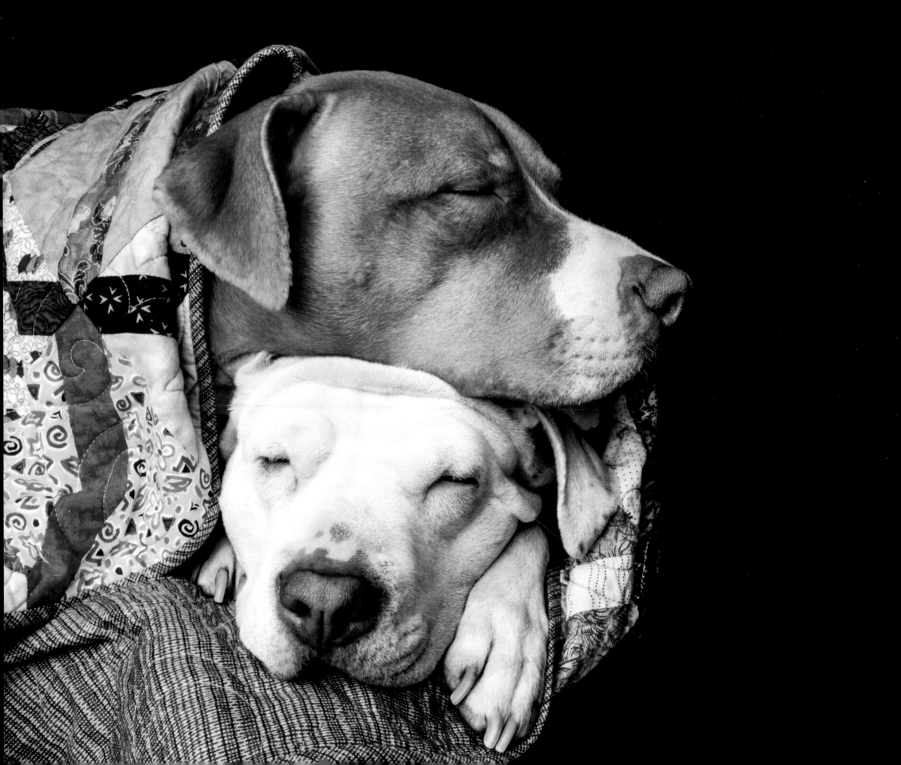

# IN CRUCIAL THINGS, UNITY.
# IN IMPORTANT THINGS, DIVERSITY.
# IN ALL THINGS, GENEROSITY.

GEORGE H.W. BUSH

# AMERICA IS HOPE.
# IT IS COMPASSION.
# IT IS EXCELLENCE.
# IT IS VALOR.

PAUL TSONGAS

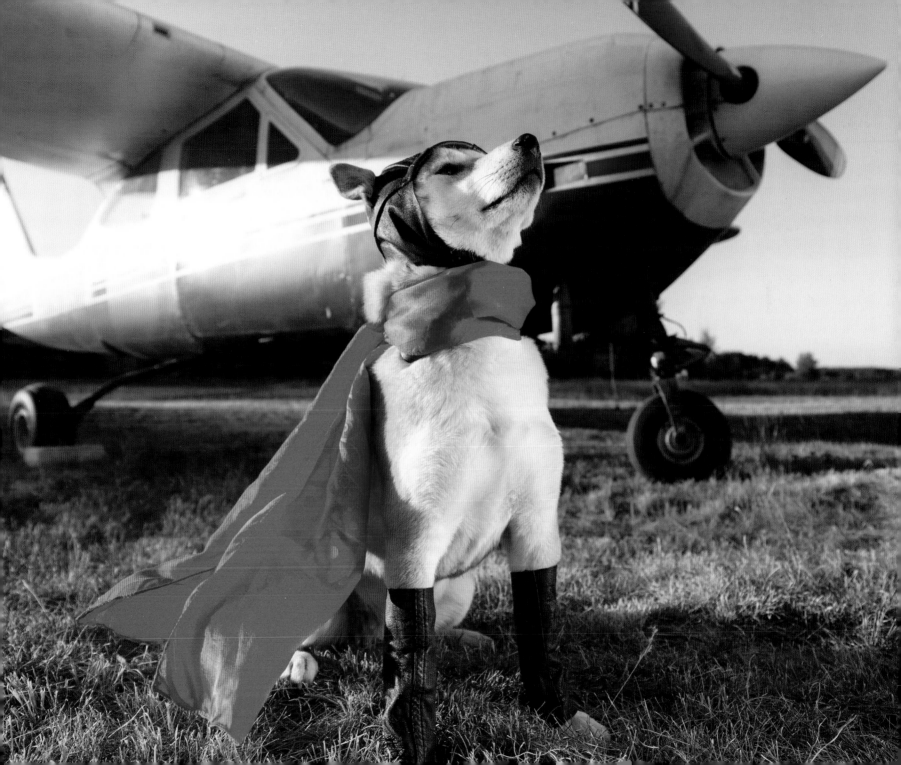

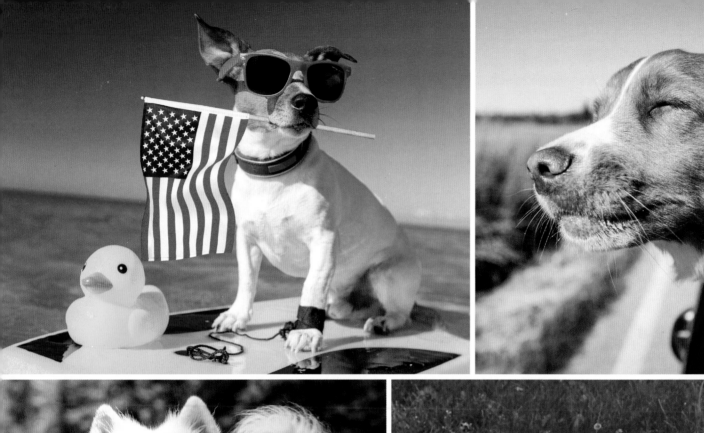

GO FETCH
FREEDOM
AND
LIBERTY

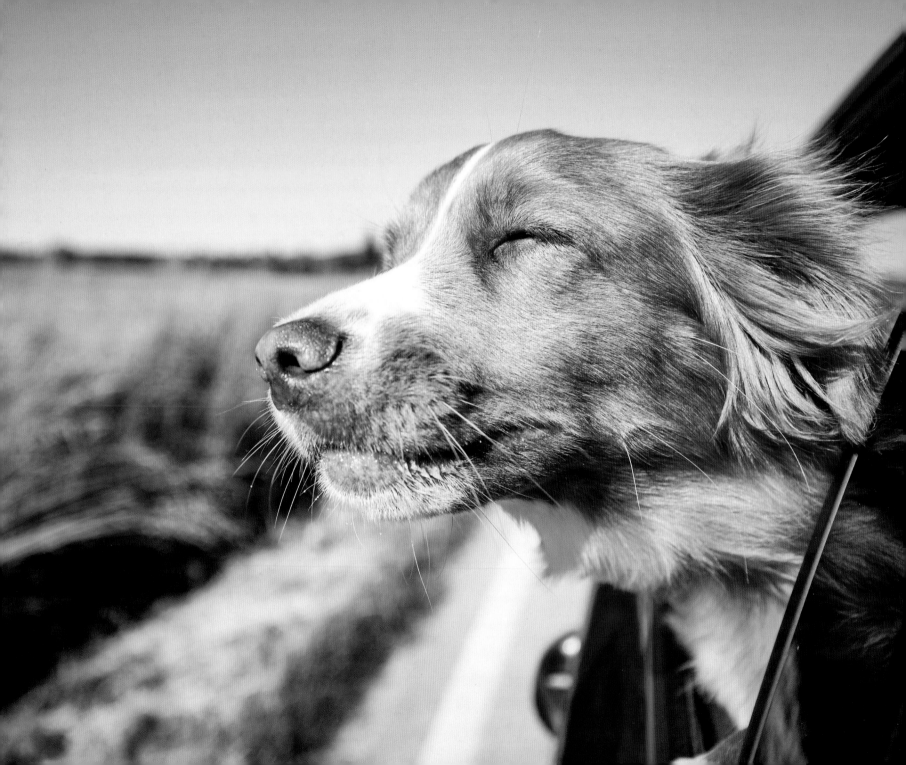

# AMERICA, TO ME, IS FREEDOM.

WILLIE NELSON

# MAY THE SUN IN HIS COURSE VISIT NO LAND MORE FREE, MORE HAPPY, MORE LOVELY

# THAN THIS OUR OWN COUNTRY!

DANIEL WEBSTER

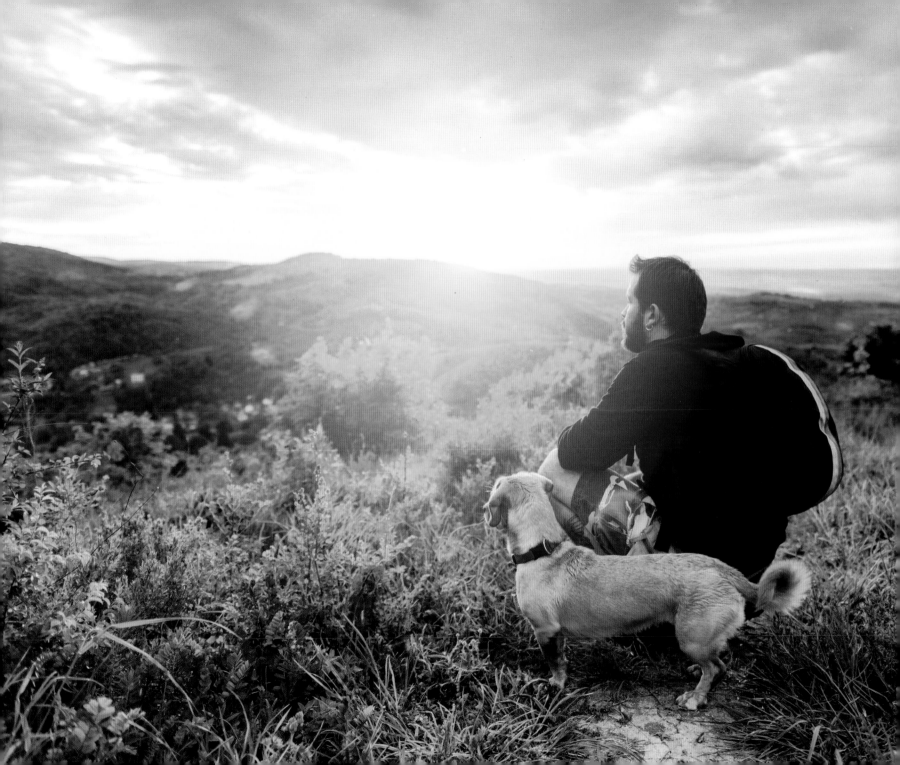

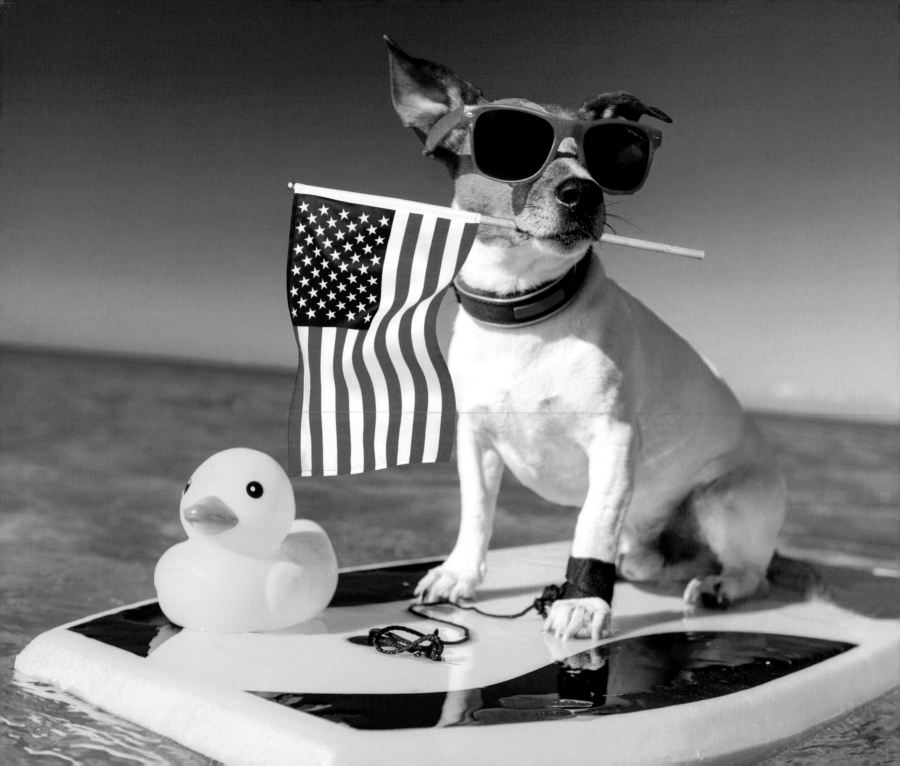

# WHERE THE AIR IS FULL OF SUNLIGHT AND THE FLAG IS FULL OF STARS.

HENRY VAN DYKE

# FROM EVERY MOUNTAINSIDE, LET FREEDOM RING.

MARTIN LUTHER KING, JR.

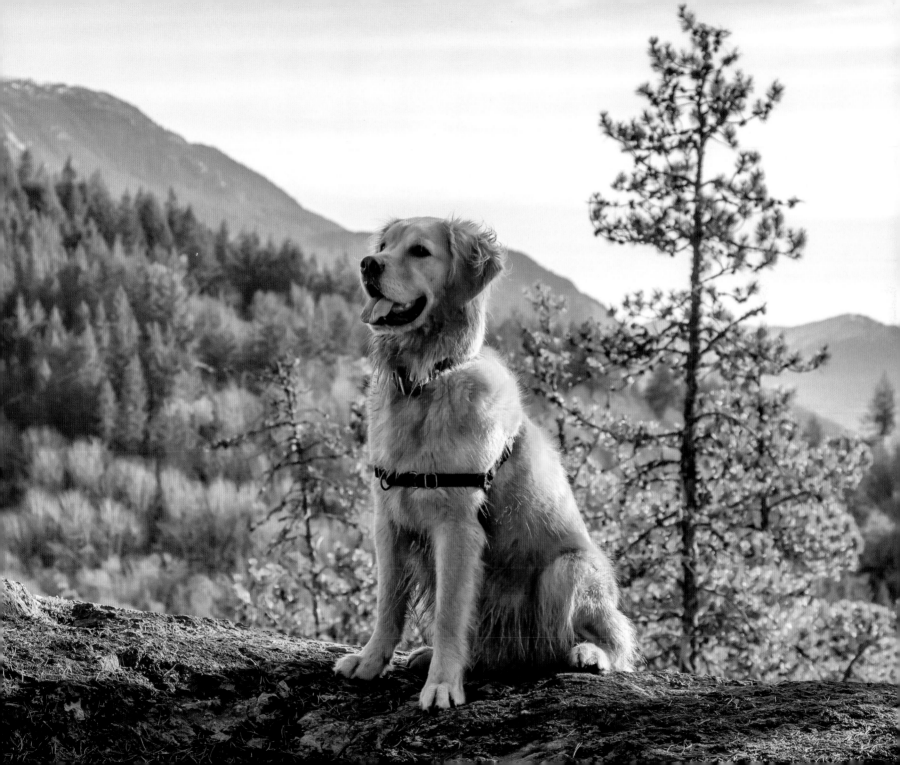

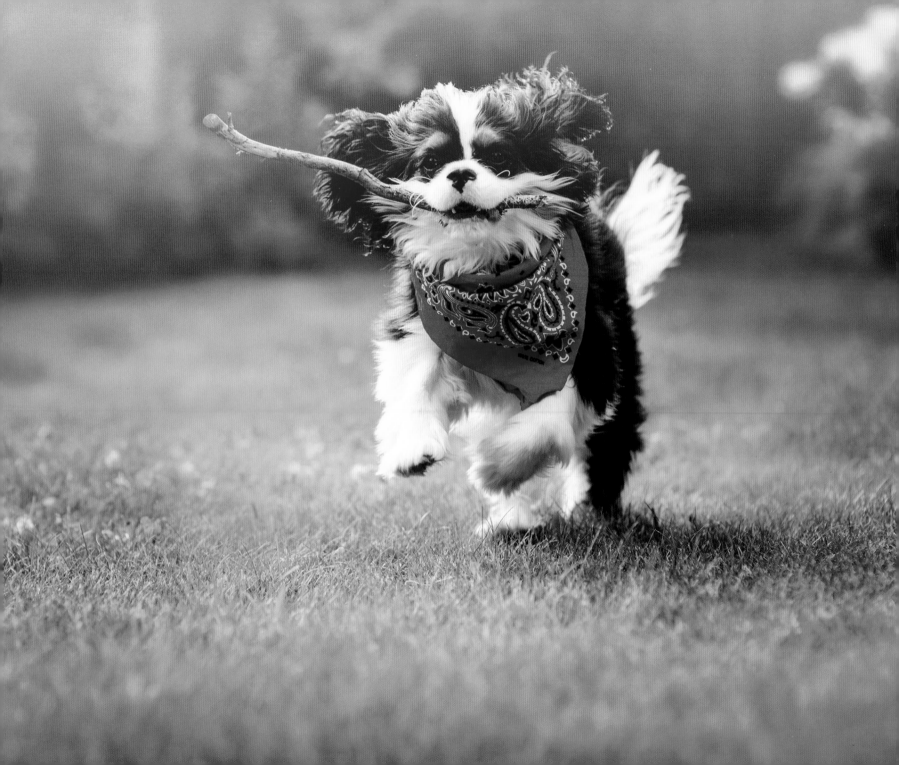

# FREEDOM LIES IN BEING BOLD.

ROBERT FROST

# THOSE WHO EXPECT TO REAP THE BLESSINGS OF FREEDOM MUST, LIKE MEN, UNDERGO THE FATIGUES OF SUPPORTING IT.

THOMAS PAINE

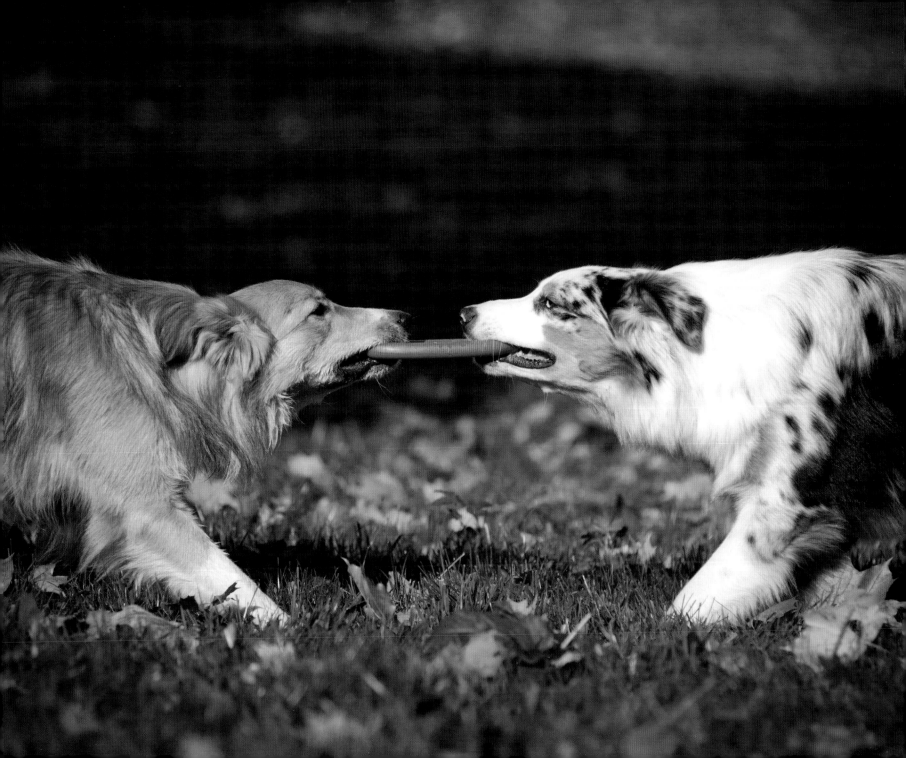

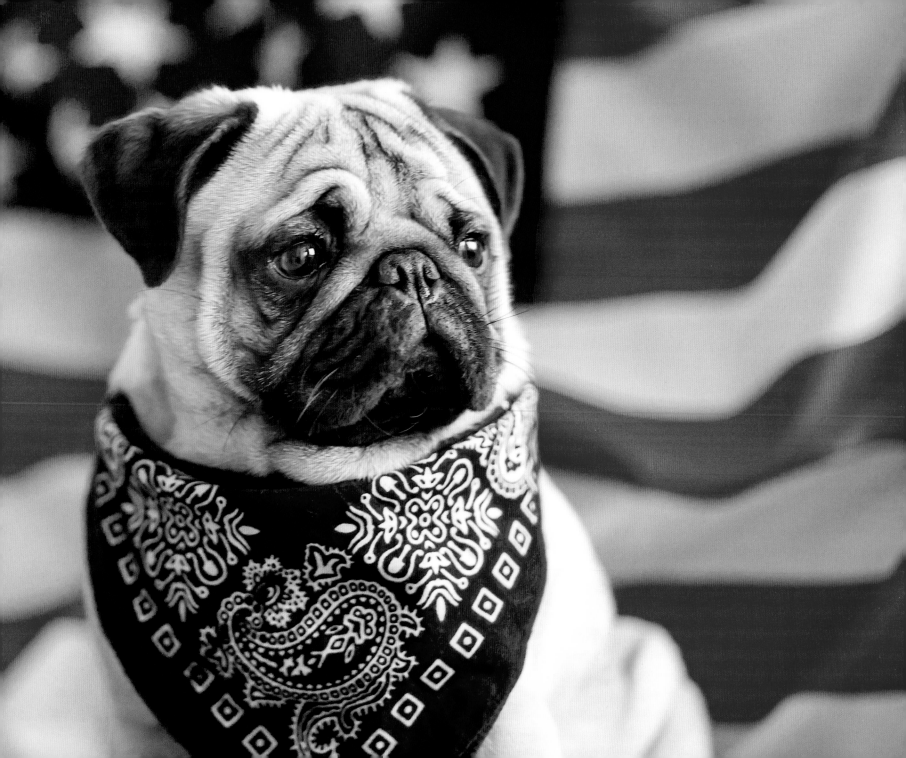

THE THINGS THAT THE FLAG STANDS FOR
WERE CREATED BY THE EXPERIENCES
OF A GREAT PEOPLE.
EVERYTHING THAT IT STANDS FOR
WAS WRITTEN BY THEIR LIVES.
THE FLAG IS THE EMBODIMENT,
NOT OF SENTIMENT, BUT OF HISTORY.

WOODROW WILSON

# YOU CAN'T SEPARATE PEACE FROM FREEDOM

## BECAUSE NO ONE CAN BE AT PEACE UNLESS HE HAS HIS FREEDOM.

MALCOLM X

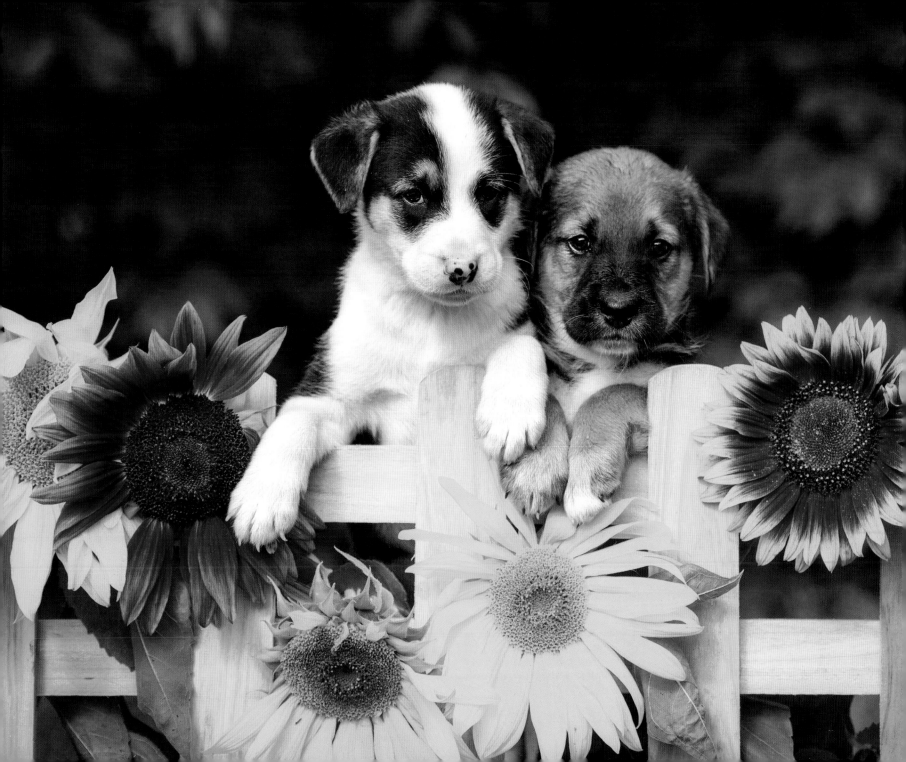

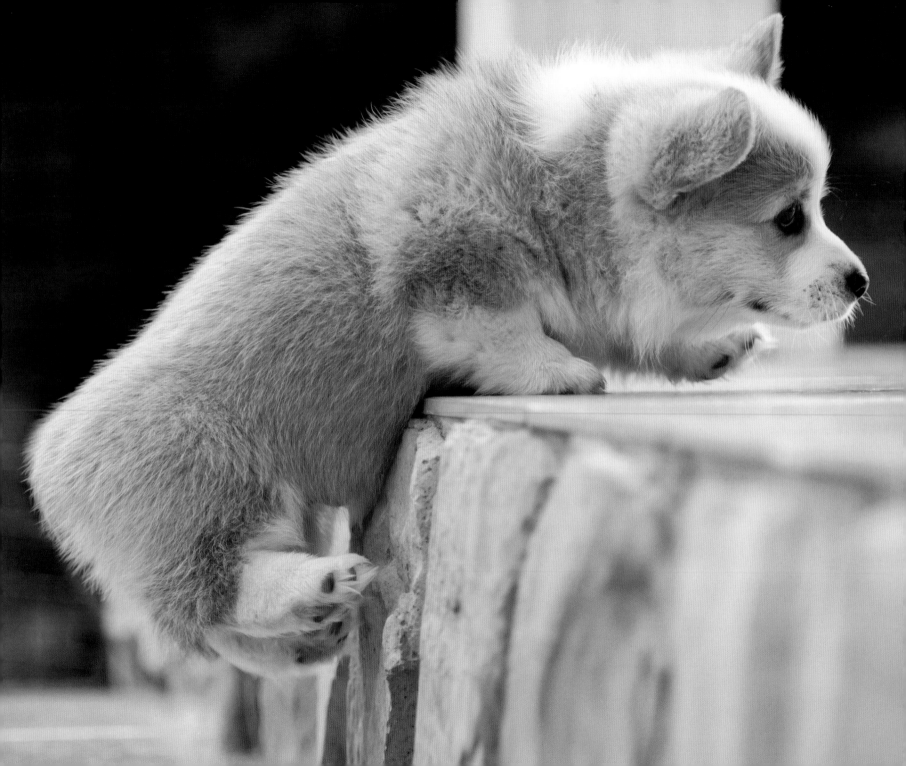

# IN THE TRUEST SENSE, FREEDOM CANNOT BE BESTOWED; IT MUST BE ACHIEVED.

FRANKLIN D. ROOSEVELT

# FREEDOM
## IS NOTHING BUT
## A CHANCE TO BE BETTER.

ALBERT CAMUS

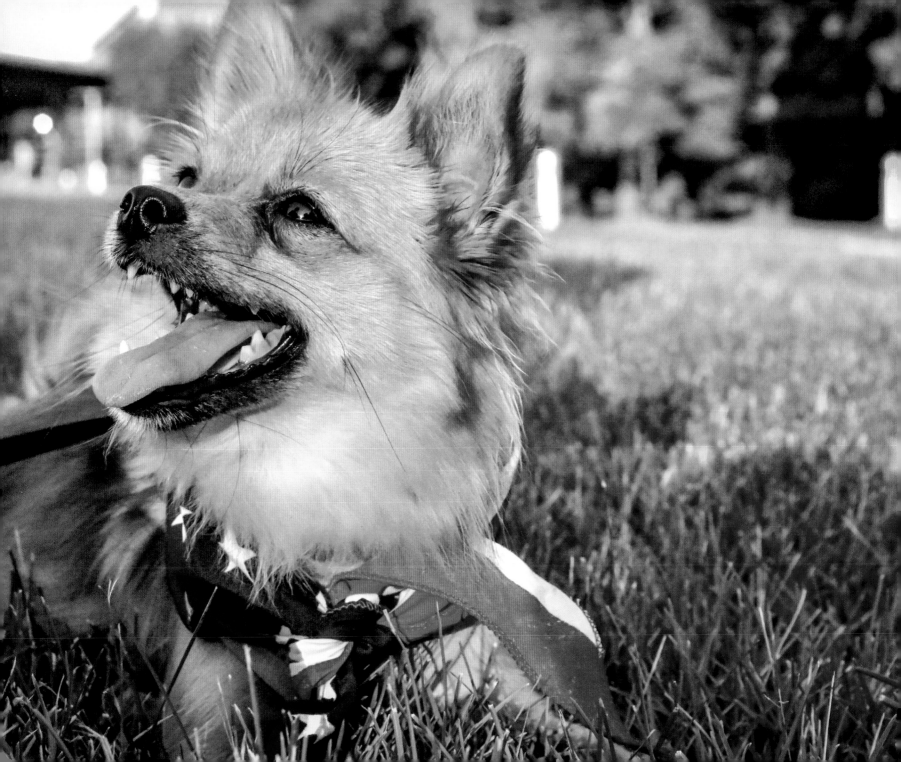

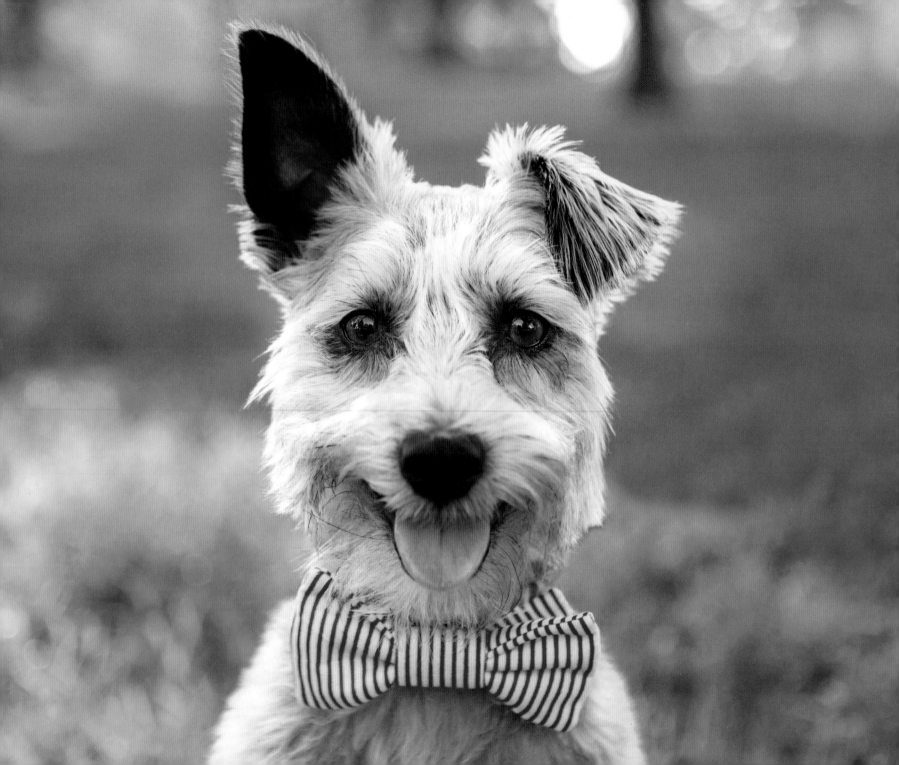

MAY WE THINK OF FREEDOM,
NOT AS THE RIGHT TO DO AS WE PLEASE,
BUT AS THE OPPORTUNITY
TO DO WHAT IS RIGHT.

PETER MARSHALL

# LAUGHTER IS AMERICA'S MOST IMPORTANT EXPORT.

WALT DISNEY

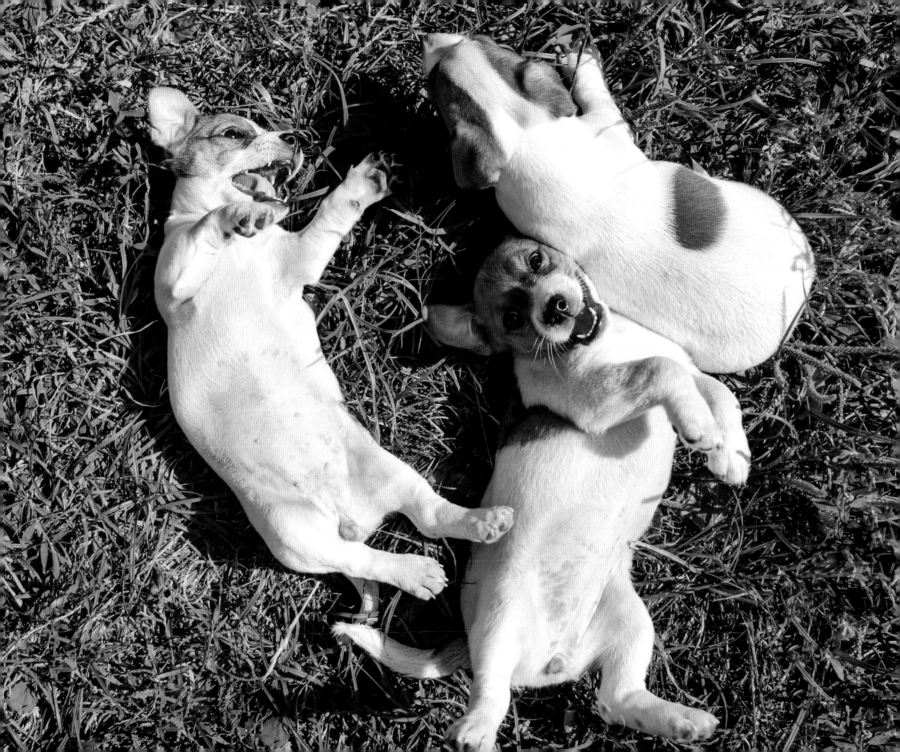

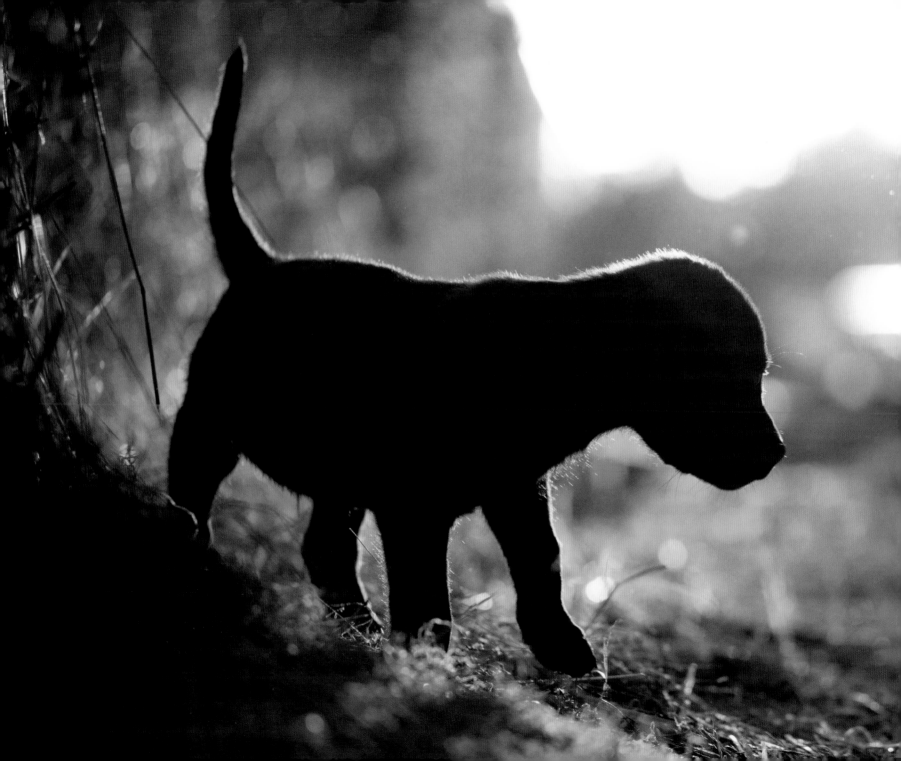

I THINK OF A HERO
AS SOMEONE WHO UNDERSTANDS
THE DEGREE OF RESPONSIBILITY
THAT COMES WITH HIS FREEDOM.

BOB DYLAN

# FREEDOM
## IS ONE OF THE
### DEEPEST AND NOBLEST
### ASPIRATIONS OF THE
### HUMAN SPIRIT.

RONALD REAGAN

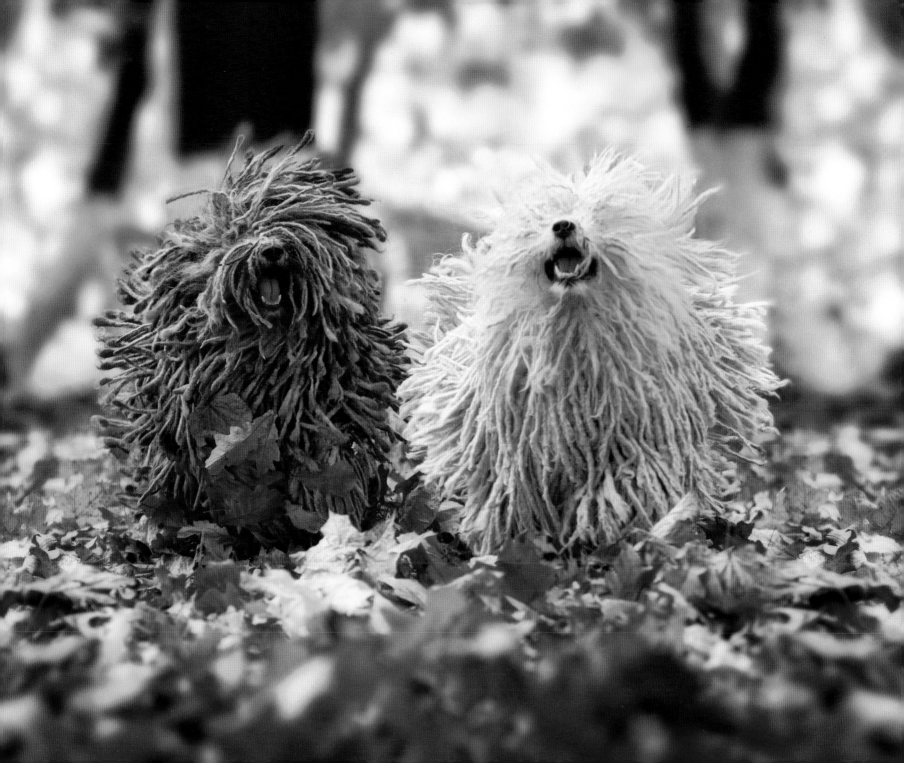

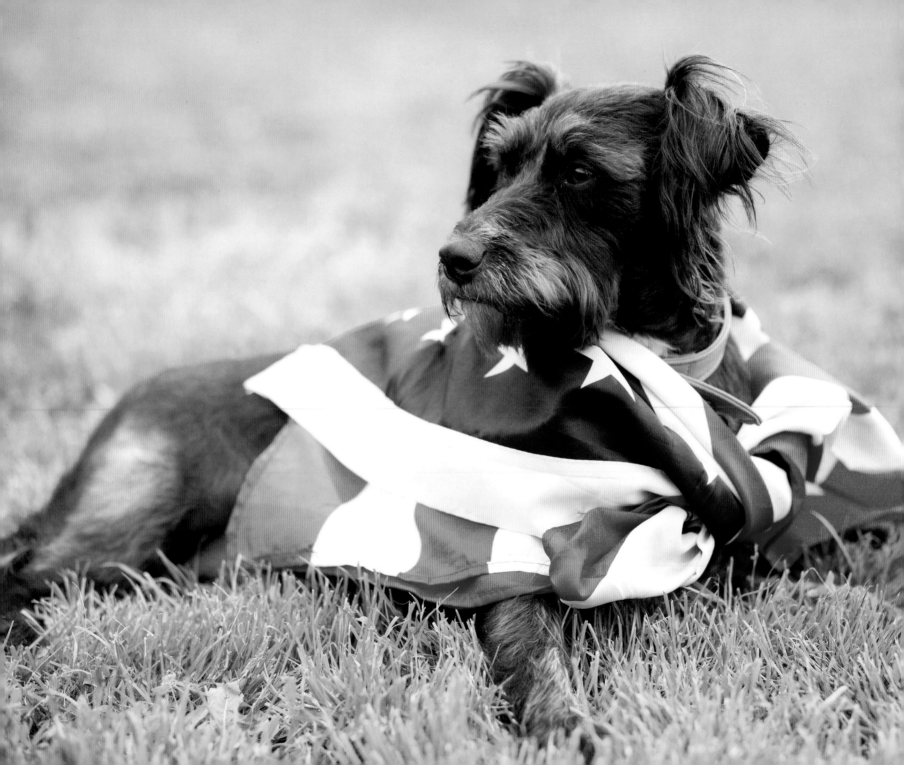

# WHERE LIBERTY DWELLS, THERE IS MY COUNTRY.

BENJAMIN FRANKLIN

WE NEED AN AMERICA WITH THE WISDOM OF EXPERIENCE. BUT WE MUST NOT LET AMERICA GROW OLD IN SPIRIT.

HUBERT HUMPHREY

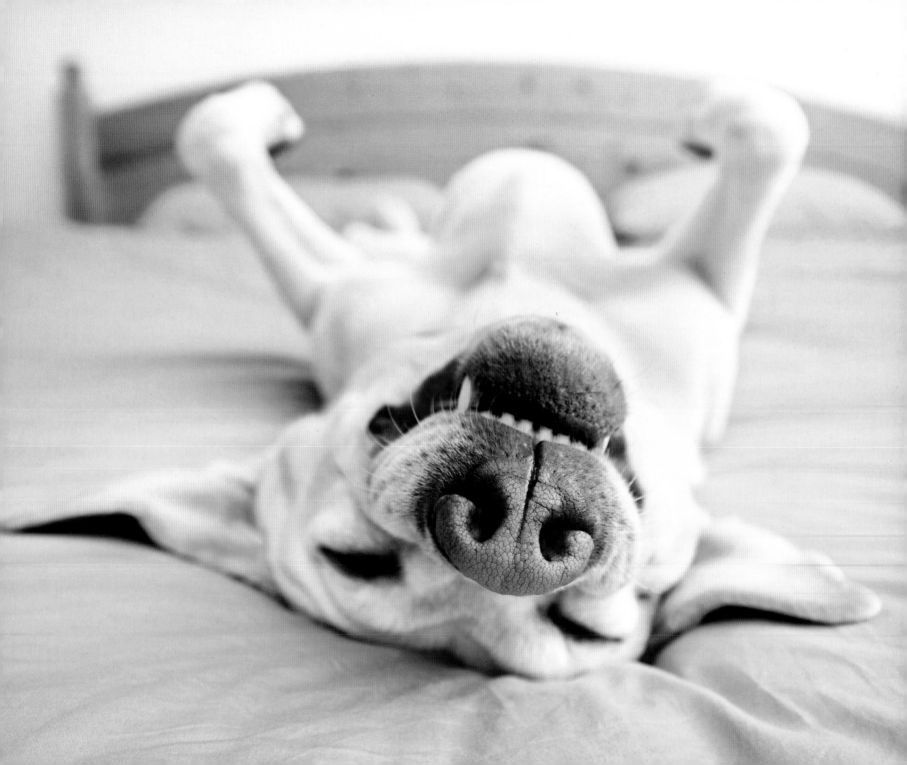

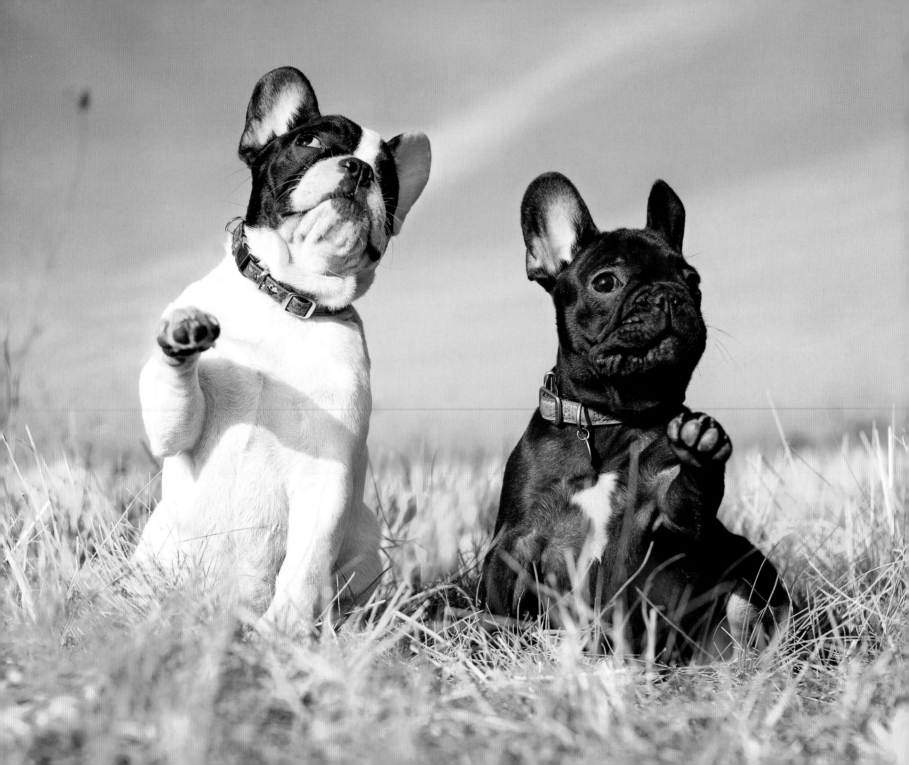

# AMERICA IS A VAST CONSPIRACY TO MAKE YOU HAPPY.

JOHN UPDIKE

THE WINDS THAT BLOW THROUGH THE WIDE SKY IN THESE MOUNTS, THE WINDS THAT SWEEP FROM CANADA TO MEXICO, FROM THE PACIFIC TO THE ATLANTIC— HAVE ALWAYS BLOWN ON FREE MEN.

FRANKLIN D. ROOSEVELT

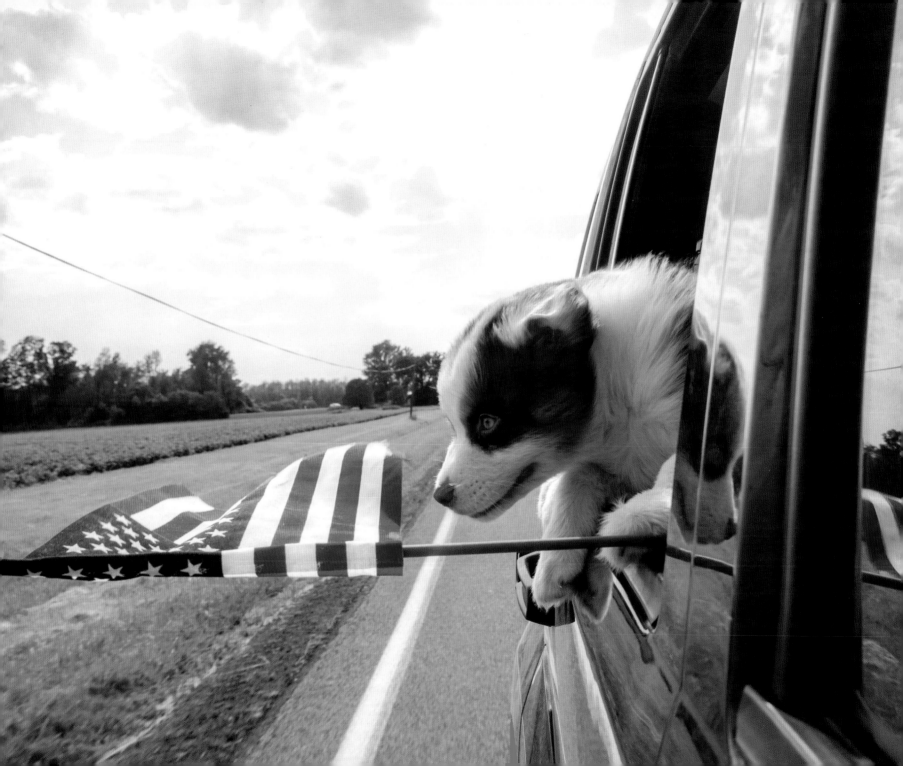

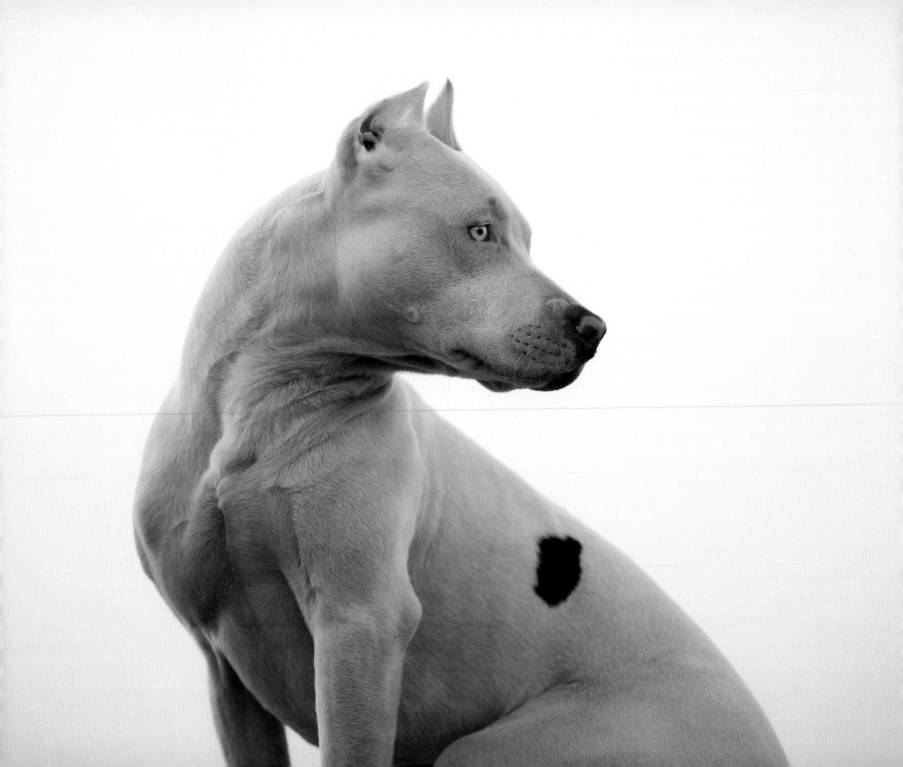

# THE PRICE OF FREEDOM IS ETERNAL VIGILANCE.

THOMAS JEFFERSON

# A PEOPLE THAT VALUES ITS PRIVILEGES ABOVE ITS PRINCIPLES SOON LOSES BOTH.

DWIGHT D. EISENHOWER

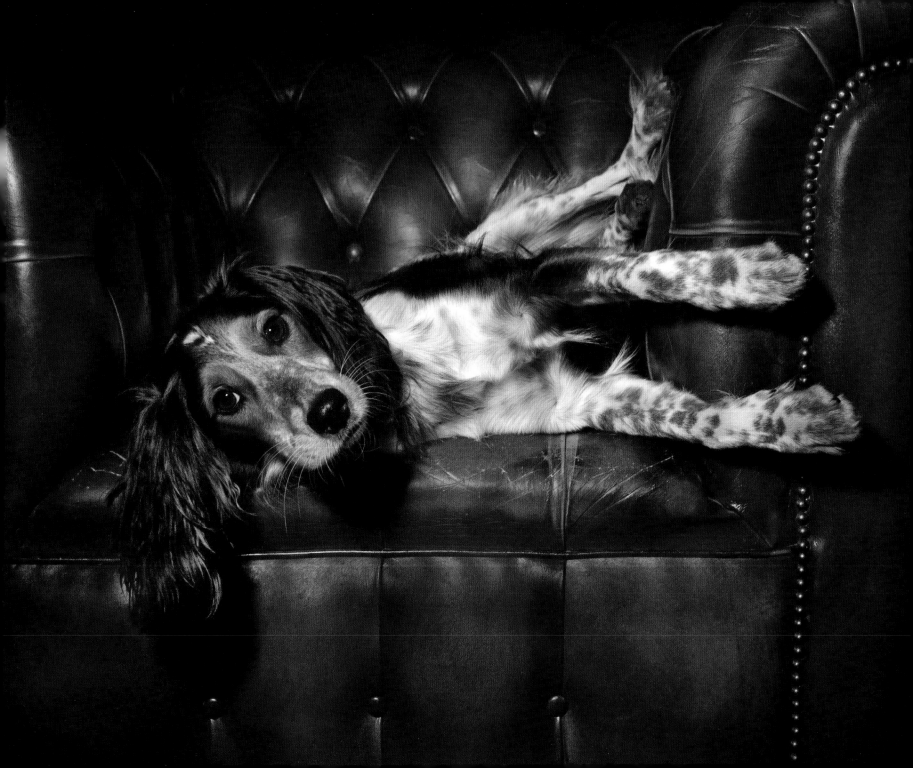

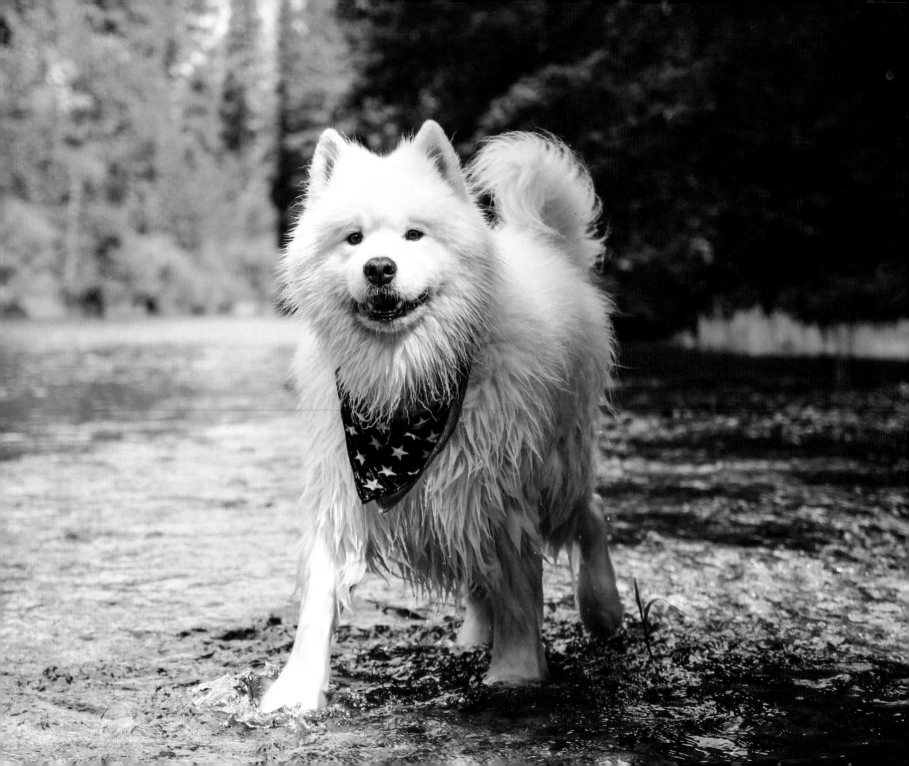

THOSE WHO WON OUR INDEPENDENCE

BELIEVED LIBERTY TO BE

THE SECRET OF HAPPINESS

AND COURAGE TO BE

THE SECRET OF LIBERTY.

LOUIS D. BRANDEIS

# WE MUST BE FREE
## NOT BECAUSE WE CLAIM FREEDOM,
## BUT BECAUSE WE PRACTICE IT.

WILLIAM FAULKNER

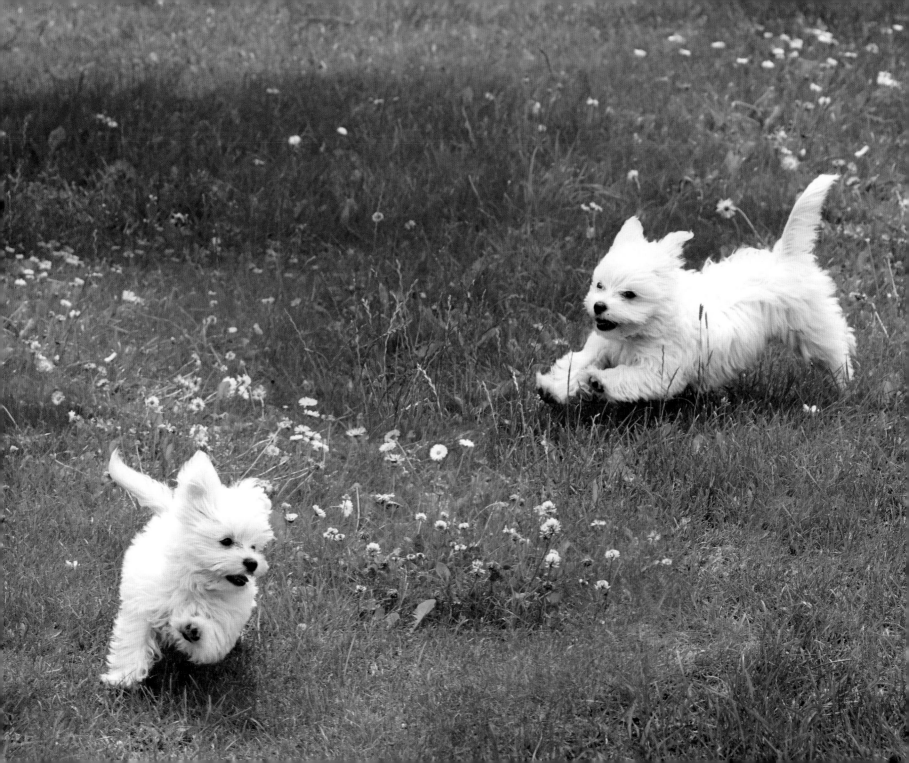

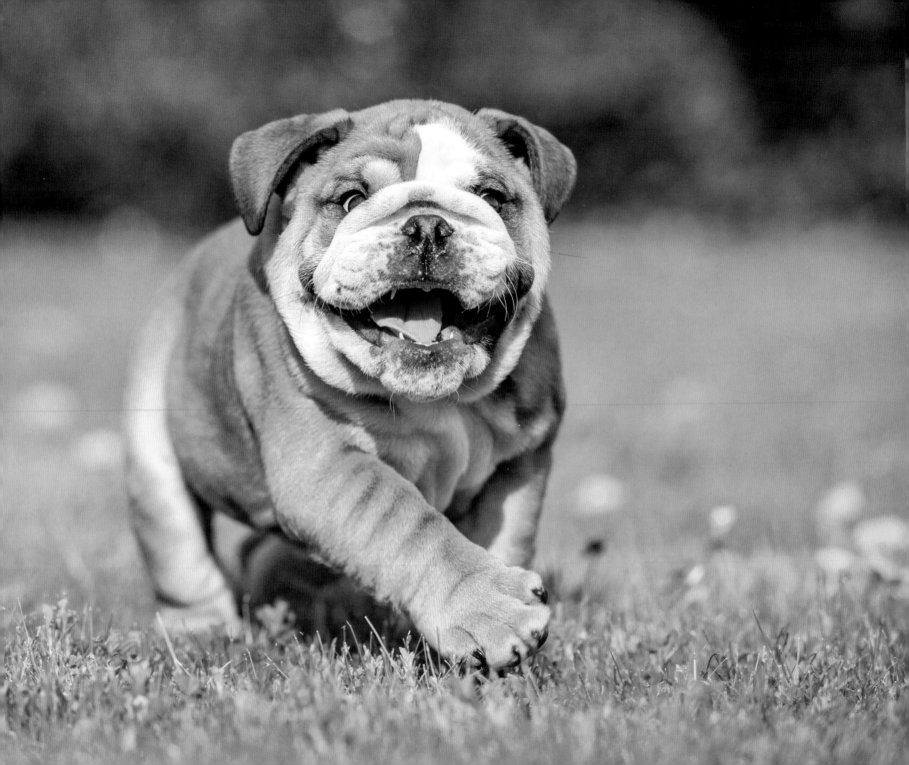

# AND FREEDOM IS
# WHAT AMERICA MEANS
## TO THE WORLD.

AUDIE MURPHY

WHEN AN AMERICAN SAYS THAT HE LOVES HIS COUNTRY,
HE MEANS NOT ONLY THAT HE LOVES THE NEW
ENGLAND HILLS, THE PRAIRIES GLISTENING
IN THE SUN, THE WIDE AND RISING PLAINS,
THE GREAT MOUNTAINS, AND THE SEA.
HE MEANS THAT HE LOVES AN INNER AIR, AN
INNER LIGHT IN WHICH FREEDOM LIVES AND IN WHICH
A MAN CAN DRAW THE BREATH OF SELF-RESPECT.

ADLAI STEVENSON

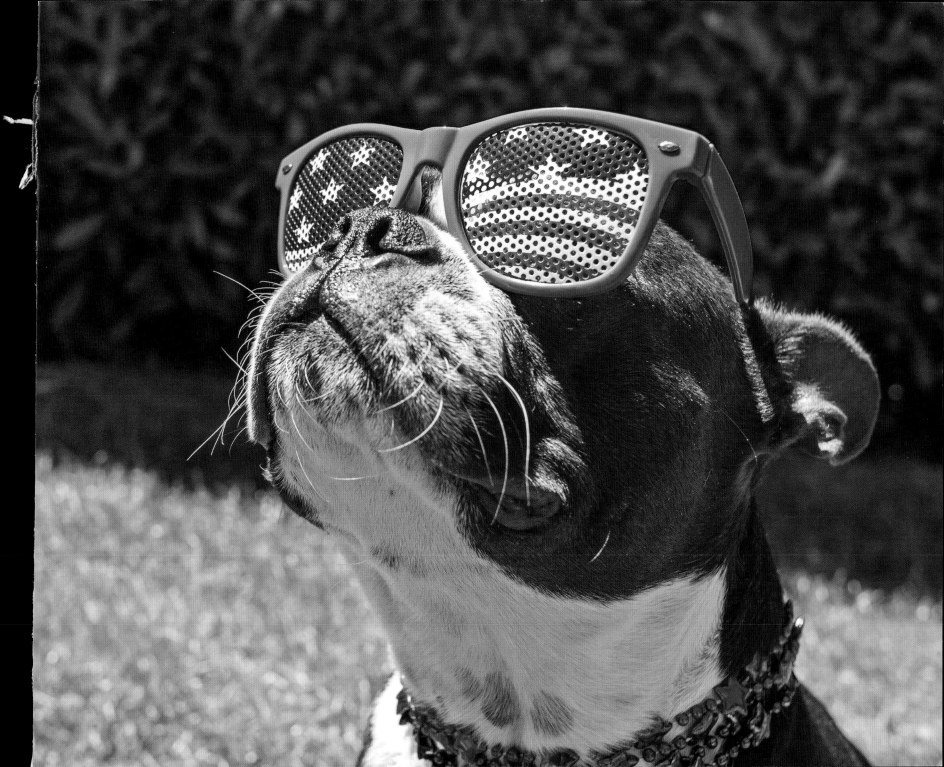

# AMERICA IS
# NOT MERELY A NATION
# BUT A NATION OF NATIONS.

LYNDON B. JOHNSON